M000311938

IMAGES
of America

DAMARISCOTTA
LAKE

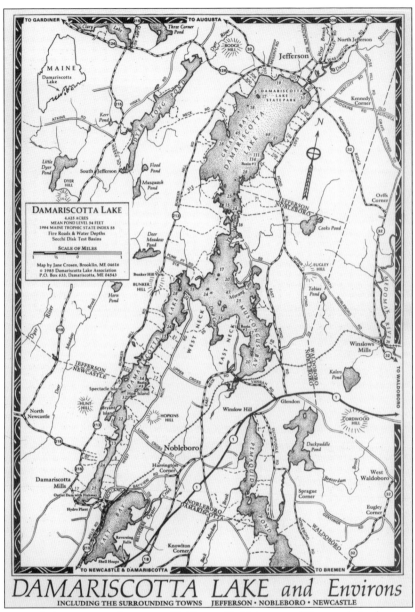

DAMARISCOTTA LAKE *and* Environs

INCLUDING THE SURROUNDING TOWNS JEFFERSON · NOBLEBORO · NEWCASTLE

Damariscotta Lake connects the towns of Jefferson, Nobleboro, and Newcastle in the state of Maine. The lake itself is around 12 miles long and covers more than 4,300 acres. Made up of three basins, Damariscotta Lake is the largest of the lakes and ponds in Midcoast Maine. It is home to many year-round and seasonal human residents as well as a robust alewife run and the second largest breeding loon population in southern Maine. (Damariscotta Lake Watershed Association.)

ON THE COVER: In the 1930s, George Kennedy's fresh-air taxi was a huge hit at Jefferson's Crescent Beach. Owner Kennedy and friend Harry Blanchard built a pair of pontoons with a platform on top that held a Model-T cab and engine, including the driving mechanism. Passengers sat on folding chairs. Blanchard also built a water bike for transportation from his home near the bridge to the beach. (Ralph Bond.)

IMAGES
of America

DAMARISCOTTA LAKE

Edmée Déjean, Julia McLeod,
Mary Sheldon,
and Marilyn Speckmann

ARCADIA
PUBLISHING

Copyright © 2011 by Edmée Déjean, Julia McLeod, Mary Sheldon, and Marilyn Speckmann
ISBN 978-0-7385-7509-4

Published by Arcadia Publishing
Charleston, South Carolina

Printed in the United States of America

Library of Congress Control Number: 2010939841

For all general information, please contact Arcadia Publishing:
Telephone 843-853-2070
Fax 843-853-0044
E-mail sales@arcadiapublishing.com
For customer service and orders:
Toll-Free 1-888-313-2665

Visit us on the Internet at www.arcadiapublishing.com

*Dedicated to all the volunteers who work to preserve local history and
to protect the ecology and natural beauty of Damariscotta Lake*

CONTENTS

ACKNOWLEDGMENTS

Founded in 1966, the Damariscotta Lake Watershed Association, which is a volunteer-based organization of nearly 500 member families, is committed to enhancing the quality of life in and around Damariscotta Lake, assuring enjoyment for all of its natural and human residents. Learn more at www.dlwa.org.

Organized in 1962, the Jefferson Historical Society is dedicated to the preservation of local history, lore, and artifacts. Major restoration projects include the old bandstand, the Hearse House, and the ongoing adaptive restoration of the Old Jefferson Town House, built in 1869, for use as a local history center. Interested individuals are invited to attend meetings and events and to join the society.

The Newcastle Historical Society, established in 1998, provides visitors with a doorway to the past through its museum operated in conjunction with the Taniscot Fire Engine Company, regular meetings, the Dinsmore-Flye Photographic Collection, and their website at www.newcastlemainehistoricalsociety.org.

Nobleboro Historical Society started in 1978 under the leadership of George W. Dow. Artifacts, town records, and genealogical files reflecting the life and times of Nobleboro are available in the Historical Center Museum, a restored one-room schoolhouse built in 1818. Our programs and website, www.nobleborohistoricalsociety.org, provide additional information.

Sincere thanks to the people who generously provided information, inspiration, and photographs to create this book, particularly Ralph and Priscilla Bond, Scottie Brooks, Joyce Ball Brown, Heather Chapman, Gertie Déjean, Tim Dinsmore, John Hilton, Ellen and Wilder Hunt, Forrest Hunt, Clayton Huntley, Margo Huntley, Fred Jackson, Richard and Gladys Johnston, Arthur Jones, Henry Kennedy, Gary Lawless, Maurice E. Libby Sr. and Leah (Jackson) Libby family, Thomas Moody, Eleanor O'Donnell, JoAnn and Henry Oliver, Gary Olsen, Leah Sprague, Marc Stevens, Grayce Hall Studley, Robert and Martha Bond Tompkins, Robert VanRiper, Margaret Wellman, Ellen Welsh, George Weston, Robert Wheeler, and Russ Williams.

The following books were helpful resources: *Nobleboro, Maine—A History* by Robert E. Dunbar and George F. Dow (1988); *Five Generations on a Maine Farm* by Hudson Vannah (1984); *Jefferson Historical Society's Touchstone*, Books I and II; *Ancient Domains of Maine* by Rufus Sewall (1859); *History of Ancient Sheepscot and Newcastle* by Rev. David Quimbly Cushman (1882); and the *Harold Castner Papers*.

INTRODUCTION

Damariscotta Lake, a link connecting the towns of Jefferson, Newcastle, and Nobleboro, Maine, has always had unique allure. From Native Americans and European settlers to today's residents and visitors, enterprising individuals have used the lake as a byway, food source, power source, and playground. The lake, which was impacted by dams installed at the southern end, has shaped the communities that surround it, just as those communities have shaped the lake.

Native Americans traveled and fished the waters of Damariscotta Lake, as evidenced by archaeological sites found along its shores. Pottery, stone tools, knives, and arrow points tell us about these first settlers and their lifestyles. The first known residents of the shores of Damariscotta Lake were the Wawenocks, a branch of the Algonquin. They were nomadic hunter-gatherers who used the area around Damariscotta Lake as their regular summer camping grounds.

European settlers began moving to the area as early as the 1700s. Mills were built to grind grains and saw the plentiful trees into lumber, shingles, and other necessary wood products. Early settlers and their descendants were involved in fishing and farming as they tried to scratch a living out of the rocky Maine soil.

The first substantial European settlement was founded at the southern end of the lake at Damariscotta Mills. Entrepreneur William Vaughan was the first businessman to take advantage of the power source there in 1730. Since the falls were divided into three streams, Vaughan was able to use the flowing water for many uses. He built sawmills and a gristmill to grind corn, wheat, barley, and other grains. Eventually, a fulling mill was built to clean and strengthen wool cloth made from locally raised sheep. Times were not easy, however, with the threat of Indian conflicts always present.

Vaughan and his business partner, James Noble, acquired title to vast properties on either side of the lake, as well as rights to the falls at Damariscotta Mills. The lake was known as Vaughan Pond and Damariscotta Pond for periods of time before residents settled on Damariscotta Lake.

The Damariscotta Lake falls were important for another reason besides power—the falls were needed for the annual run of the alewives, which provided an important food source and industry to the area. Each spring, thousands of alewives, which are closely related to herring, returned from the ocean waters of the Atlantic to reach their spawning grounds in Damariscotta Lake. As early as 1741, the Commonwealth of Massachusetts took steps to protect the fishery by requiring fish passage to be installed with dams. The first fish ladder was built in Damariscotta Mills in 1809 and continues to be improved. Currently the Fish Ladder Restoration Project is rebuilding the whole ladder.

Smoked alewives were an important food source from around 1790 to 1900, and both fresh and smoked fish were peddled locally by horse and wagon. Salted and pickled alewives were shipped in barrels to the West Indies and other markets. In 1896, there were at least eight smokehouses on the stream. Though alewives continued to be sold into the mid-1900s, their appeal as human food waned. The fish began to be sold for fishmeal to be fed to animals. Now they are sold primarily as lobster bait.

Settlers began to move north to the head of the lake in Jefferson, which was originally named Balltown, in the latter half of the 1700s. Brothers Samuel and Joseph Jackson rowed from Damariscotta Mills north to the head of the lake to establish the earliest mill on Jackson, later Davis, Stream in 1780. Many of these first residents were farmers and woodsmen who cut wood, grew grains, and raised sheep to feed the numerous mills built along Davis Stream.

Small communities formed in clusters near the mills and near the lake. The North Village in Jefferson around the Weeks-Meserve Mill had numerous shops and stores, fine houses, blacksmith shop, dentist office, cemetery, and boarding home for travelers. Around the bridge area, there was Haskell's Tavern, the Lake House, houses, the first post office, and several stores.

All around the lake, settlers took advantage of the rich natural resources of the area and industries flourished, including forestry, milling, farming, ice harvesting, shipbuilding, fish harvesting, and small factories. The population of the area grew and many people lived comfortable, sustainable lives.

In Damariscotta Mills, factories included a foundry, which produced iron products, and a match factory above the site of Vaughan's double sawmill. The match factory started in 1870 and grew to a crew of 35 employees by 1890. It was eventually sold and replaced by a leatherboard factory, which used scraps of leather and turned them into chair bottoms, wall paneling, and leather heels for shoes until the factory burned in 1921.

In the latter part of the 1800s, before the invention of electric refrigeration, ice harvesting was an important local business. Ice cut from Damariscotta Lake was shipped by rail and boat to many distant cities. Local ice-cutters continued to fill summer residents' iceboxes into the mid-1900s.

Farming was an important occupation for the majority of families in the 1800s, though even the largest farms seemed small by today's standards. Nobleboro's biggest farmer was Charles Vannah. In 1849, Vannah produced 175 bushels of corn and 100 bushels of potatoes, among other crops, and had seven milk cows. Many farmers raised sheep for wool, oxen for doing the heavy work on the farm, and horses for travel.

The lake was an important byway, carrying people and goods from the more settled area of Damariscotta Mills to the northern parts of the lake. Transportation advanced from barges to larger steamboats. Steamboats connected with the railroad so that a traveler could buy a ticket from Jefferson to New York City, switching from boat to train in Nobleboro.

By the beginning of the 1900s, many resource-based industries began to decline. What took their place, eventually, was tourism and recreation. The 1900s were an era of increasing recreational use of the lake with cottages, hunting and fishing lodges, and boys and girls camps developing around the shore. Sailing, water skiing, motor boating, and fishing were all popular pastimes. In the winter, people enjoyed ice fishing and iceboating. The first cottage on Great Bay was built around 1912; it began a new industry in a time when farms were abandoned and mills shut down. Since that time, many summer cottages have popped up all along the lakeshore.

In 1923, the first power plant was built to convert the energy of the falling water at Damariscotta Mills into electricity. The hydropower dam raised the lake level higher than the rise created by the first mills.

Damariscotta Lake has been used for food, transportation, business, and pleasure. It has been and remains a landmark and refuge for those who work and live beside it.

The photographs in this book are organized geographically by the three main basins of the lake—the South Arm and Damariscotta Mills; Muscongus Bay; and Great Bay and Davis Stream. We invite you to explore how early residents of Nobleboro, Newcastle, and Jefferson interacted with the lake they shared.

One

SOUTH ARM AND
DAMARISCOTTA MILLS

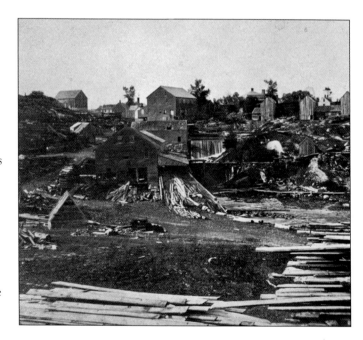

The power of falling water drew the first settlers to make Damariscotta Mills a bustling industrial area. This photograph of the western millstream from 1883 shows Nathaniel Bryant's early mill in the foreground. Behind Bryant's mill was the original William Vaughan gristmill of 1730, which had three grinding stones. These mills operated until the late 1800s. In 1863, Joseph Haines built the match factory seen at the top of the photograph. (Newcastle Historical Society Dinsmore-Flye Collection.)

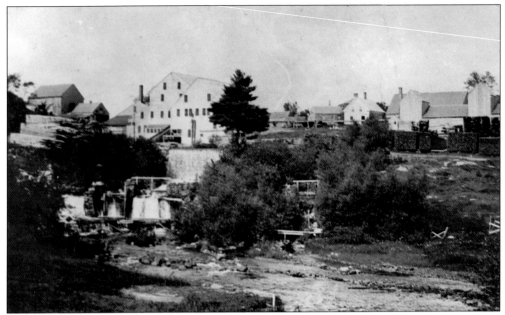

Diamond Match Company took over operation of the factory from Joseph Haines in 1882 and enlarged and improved it, employing a crew of 35 men and women in 1890. Pine was cut into two-inch-wide strips and put in small drying houses (right). Sawing a space between each match and leaving them connected at the base created a series of matches. The phosphorous dipping process was done in Portland and Boston. (Robert Wheeler.)

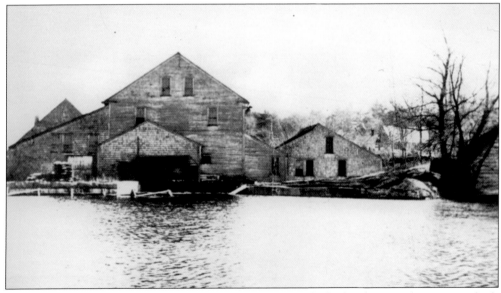

On the lakeside of the match factory, water entered through the headgate or sluice gate, which was protected by a heavy iron screen (center) 45 feet above the turbine. The falling water turned the turbine, which powered the belts and saws that cut the pine logs. In 1891, Diamond Match Company sold the facility to Lincoln County Power Company (LCPC), which continued to produce lumber until 1906. (Arthur Jones.)

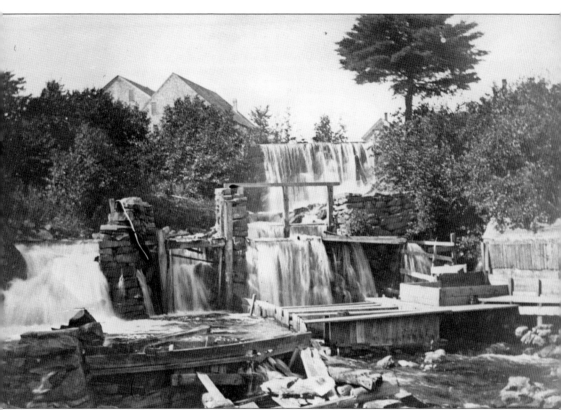

The first sawmills and gristmills of Bryant, Vaughan, and others were built on the lower level over the western and middle streams. Bryant's sawmill burned in 1883, and he lost an up-and-down-saw, a treenail machine, a shingle machine, a clapboard machine, and a gristmill. The gristmills ground cereal grains such as wheat, barley, oats, and corn. Whatever was ground in the mill increased in value, giving birth to the old saying, "That is grist to the mill," which literally means, "That is a source of profit." An important iron foundry, which was owned by Samuel Glidden, John Madigan, and others over the decades, operated on the upper western stream from the 1840s until 1870 when it burned. The eastern stream (not shown, to the right) was the narrowest of the three streams and was used by migrating alewives. Over the decades, mills came and went as they were destroyed by fire and rebuilt or changed ownership. In 1906, this lower level became the location of the new leatherboard factory. The building frame, which measured 50 feet by 120 feet, was beginning to take shape in this photograph. (Robert Wheeler.)

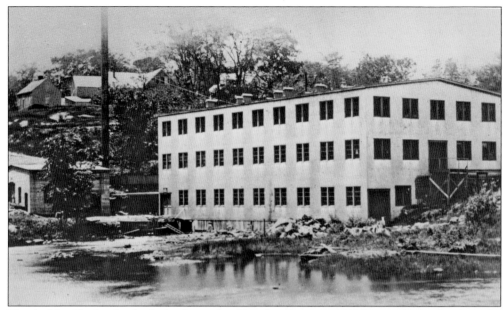

Thrifty New Englanders built the Centrifugal Leather Factory in 1906 using the lumber from the dismantled match factory and remains of other mills. It was the largest building in Damariscotta Mills, and both the western and middle streams flowed under the building to turn the waterwheels. There was also a coal-burning boiler that sent steam for heat from the plant to the drying houses, where large sheets of closely stacked leatherboard dried. (Robert Wheeler.)

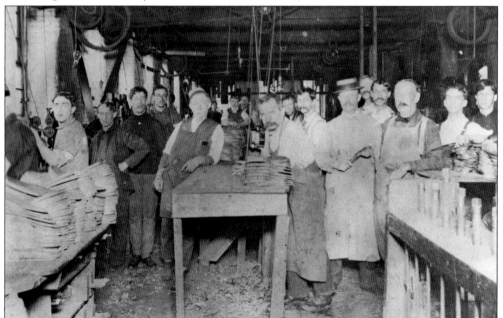

Until the leatherboard factory burned in August 1921, scraps of leather animal hides were hauled from the railroad station by horse-drawn carts for processing into leatherboard for chair bottoms, wall paneling, and leather heels for shoes. When sales were slow or hides difficult to obtain, the waterpower was sold to Lincoln County Power Company (LCPC) to generate electricity. LCPC was formed by Herman Castner and Elmer Whitehouse. (Nobleboro Historical Society.)

Herman Castner, the leatherboard factory manager, had a substantial home on the island that divided the western and eastern streams. He lived there until 1921 when the factory was destroyed by fire from overheated bearings. According to the *Lincoln County News*, "Engineer poured water on burning oil which quickly spread flame." The partners decided to move the factory to Richmond. The Castner home was rented for a while but was torn down in 1952. (Robert Wheeler.)

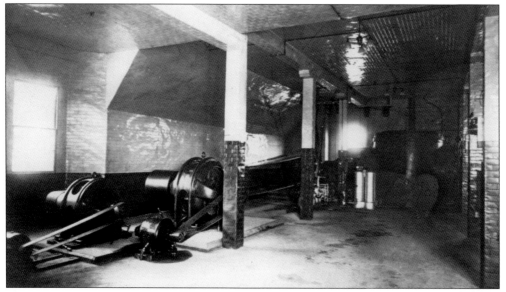

Electric power was generated in the lower level of the leatherboard factory. Falling water from the western stream turned turbines inside a tall, metal cylinder (back left). The turbines drove the belts and the generator to produce electric power. LCPC promptly built a new brick power plant on the Newcastle side of the stream after the fire and continued to produce electric power until they had financial problems. The Central Maine Power Company purchased the power plant, the site of the burned factory, and all the water rights in 1923 and the Castner home in 1924. (Nobleboro Historical Society.)

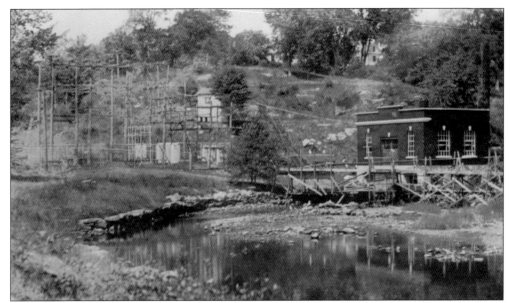

By 1925, Central Maine Power had built the first transformer field next to the powerhouse in Damariscotta Mills. In 1928, the power company permanently raised the dam and, consequently, the lake level by four feet. George B. Weston was head operator of the plant from 1921 (when owned by LCPC) to 1962. Still in operation in the same brick building with basically the same turbine and generator, the plant is now owned by Kruger Energy. (Robert Wheeler.)

Located on the Newcastle shore of the South Arm, Mile Rock shows the lines made by the changing water levels. Melrose Jones, sitting in his canoe in 1916, provides the scale. Even before Central Maine Power raised the dam in 1928, the water level rose and fell almost three feet depending on the season, amount of rainfall, and how much water the dams permitted to leave the lake and flow down the streams. (Arthur Jones.)

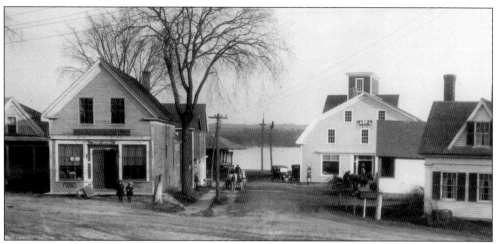

Mary Mulligan's store (left) operated from 1889 to 1927 at the corner of Bayview Road and Depot Street. Ruel T. York served as postmaster here from 1905 until his death in 1914 and was replaced by his wife, Vida, who served until 1927. At the end of Depot Street were Great Salt Bay and the railroad station. The large J.B. Ham Company, a grain, feed, and flour store, was located across the road along the railroad tracks. The small house on the right is still a residence in Damariscotta Mills, but none of the other buildings remain. (Nobleboro Historical Society.)

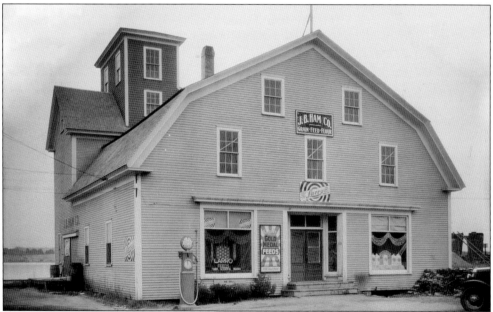

This photograph from 1931 shows the J.B. Ham Company store built by John Coombs around 1906 in Damariscotta Mills, where grains were delivered in railroad cars or by farm wagon. Customers could buy large bags of grain for animal feed or just a small bag of milled flour. Sam Rankins, a large, hardworking, jovial man, managed the store, and people came to enjoy listening to his stories. The tall, square silo close to the railroad cars in the background had a motorized conveyor system of small buckets for carrying grain to the top of the silo. The silo had four compartments to store different types of grain separately. After the store closed, the building was used to pack alewives and, in the 1950s, as a commercial laundry service. It was torn down in 1974. (Newcastle Historical Society Dinsmore-Flye Collection.)

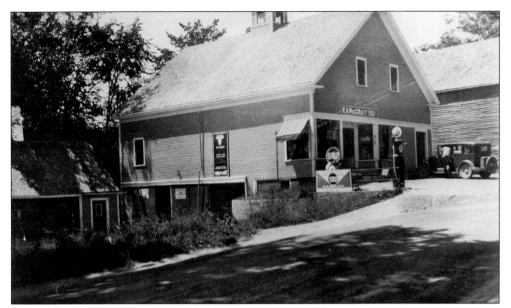

The McGray Store in Damariscotta Mills was run by Ernest McGray from 1915 to 1956, part of that time with his brother William. They sold everything from beef, grain, and vegetables to coffee and tea—and even gloves and underwear. They had a cracker barrel and potbellied stove, and they delivered their goods to their customers' doors. The store building was originally constructed in 1892 as a stable, but it became a store as horses went out of fashion and automobiles become more common. It now houses Alewives Fabrics Store. (Nobleboro Historical Society.)

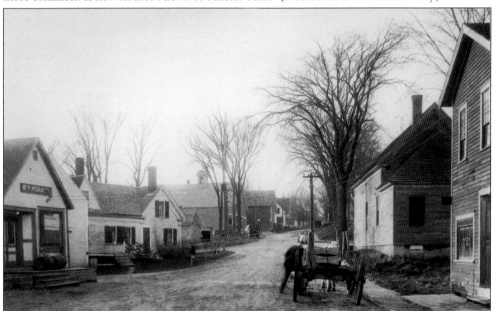

In 1926, William McGray opened the small W.P. McGray Store near the H.B. Ham Company on Depot Street in Damariscotta Mills after he and his brother Ernest McGray disagreed about expanding the store they had run together since 1915. The building, just down the road from Ernest's store, had been constructed in 1904 and previously used as a store by Almore K. Vannah. Ernest's general store grew larger. (Robert Wheeler.)

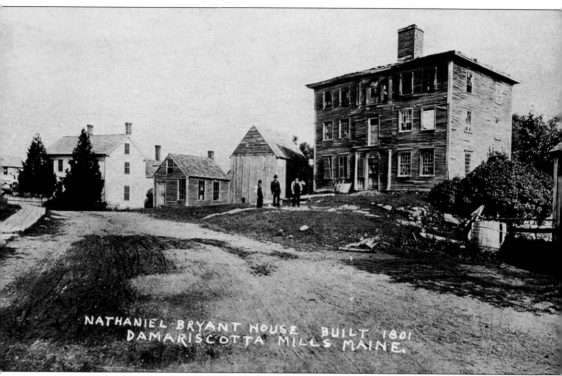

NATHANIEL BRYANT HOUSE BUILT 1801
DAMARISCOTTA MILLS MAINE.

Nathaniel Bryant II was born in 1765 and died in 1835. He was a shipbuilder on River Road in Newcastle before moving to Damariscotta Mills around 1801 to 1803. Bryant was married to Elizabeth Wall of Puritan stock. He was a prominent businessman with a shipyard and retail store at Damariscotta Mills. He owned a great deal of land on Damariscotta Lake and had a trading post at the head of Damariscotta Lake in Jefferson. Bryant was almost financially ruined during the Napoleonic War when his vessels were stolen from him. His house was torn down in the late 1800s. The Bryant family tradition of boat making continues today in Newcastle on the Damariscotta River. In this 1887 photograph, note the wooden sidewalk on the left. The three men are, from left to right, William Colson, John Eastman, and Ed Mulligan. Carleton Jones owned the house on the left, and Peter Jones's shoe shop was between the two homes. (Newcastle Historical Society Dinsmore-Flye Collection.)

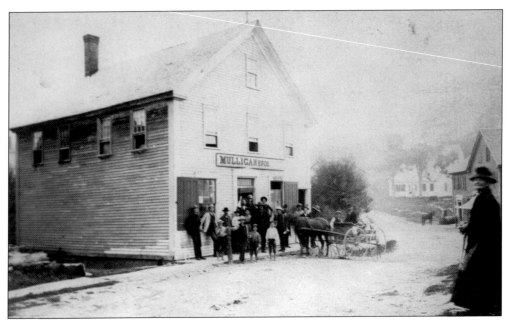

This photograph from 1886 most likely shows Dorinda Colson (right) about to cross to the Mulligan Brothers General Variety Store in a wonderful hat and cloak. Opened in 1885 in Damariscotta Mills by James Edward Mulligan and his brother John F. Mulligan, the store doubled in size in a short time, but it burned in 1890. The building had originally housed a hatter's shop in 1819 and five subsequent shops before the Mulligan brothers opened theirs, illustrating how long a building could be used and how often it could change hands. (Robert Wheeler.)

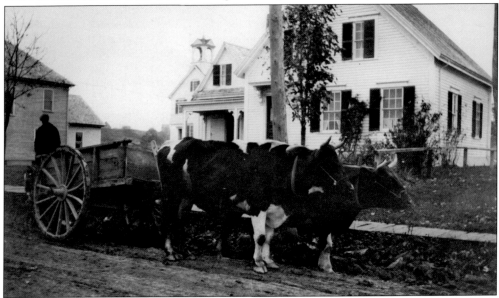

An oxcart sat in front of Francis "Ruth" and George Bryant Weston's home in the 1920s. Son George and his wife, Helen, later moved there. George has lived through over 90 years of history in Damariscotta Mills. He is now a local historian, and he still raises tomatoes every summer. The Ernest McGray home (left) still stands, but the white school building is gone. (Nobleboro Historical Society.)

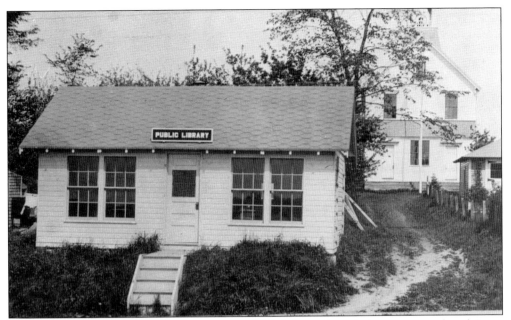

In 1930, the library was built, the Damariscotta Mills Library Association was created, and Anna Winslow was elected president of the association, a post she held until 1960. The library was free to all residents and operated until about 1980. Ernest McGray's family lived next door and found the library was "too close." In 1949, the McGrays offered a vacant property next to the McGray Store to the library association, and the library building was moved. (Nobleboro Historical Society.)

Elmira Mulligan (far left) and her sister Delia Mulligan Hale (far right) posed with their 1904–1905 classes at Longfellow Grammar School in Damariscotta Mills. Hale was also school superintendent and first selectman. The two-story white schoolhouse with a cupola (shown in the top photograph) was built in 1898 for a total cost of $1,701.78. When Nobleboro Central School opened in the 1950s, Ernest McGray purchased the school and tore it down. (George Weston.)

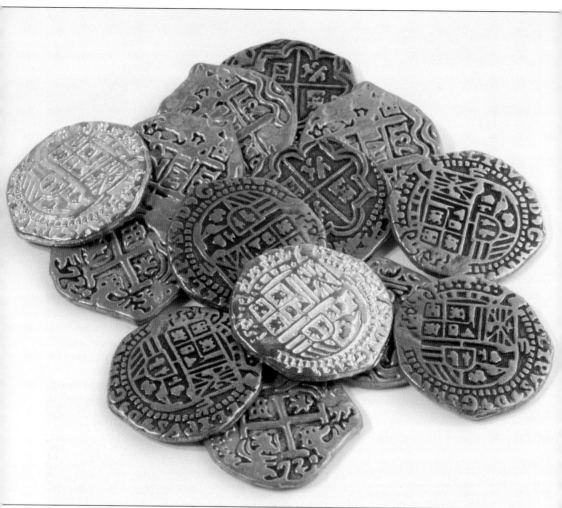

Was gold discovered at Damariscotta Mills? Around 1900, George Jones moved to Damariscotta Mills from Massachusetts. When he hired workmen to renovate the old Cottrill house, they came across a mysterious iron kettle under the floor. According to a newspaper article written in 1901, Jones took away the kettle before the workmen could look inside, and he refused to tell them what was inside. Rumors spread that it contained $11,746 in Spanish gold, but Jones would not confirm or deny the assertion. The newspaper article speculated that the gold could have been hidden by Matthew Cottrill, who built the house more than 100 years previously. A workman living near Boston related a slightly different story to E. Joshua Jones of Damariscotta Mills 50 years later. He said that he and other workers had discovered a kettle full of gold, which Jones seized immediately. According to the workman, Jones dropped one coin on the ground in his haste. The workman said he picked it up and it was still in his family's possession. Now that everyone connected with this affair is dead, we will never know whether it was a hoax or if the Spanish gold existed. (Edmée Déjean.)

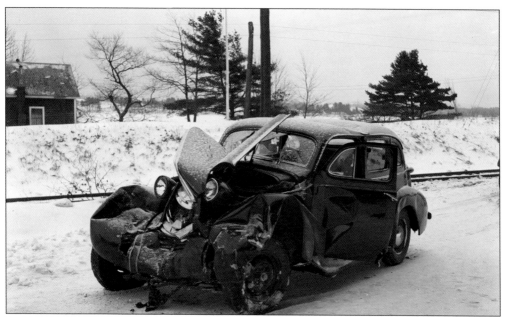

In 1939, Frank Jacob wrecked his car at Damariscotta Mills. His car was valued at around $700 new. In the 1930s and 1940s, roads in the area were mostly gravel. They were narrow and the curves were very sharp, often leading to accidents. In 1939, two-thirds of Maine farm families owned automobiles. (Newcastle Historical Society Dinsmore-Flye Collection.)

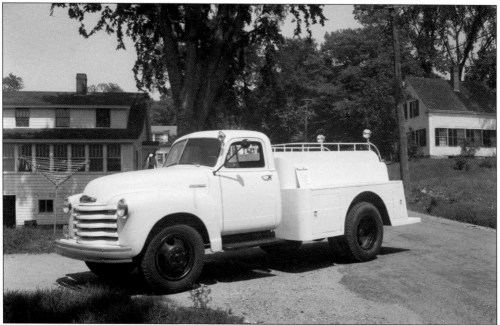

Hollis Nelson, who grew up on Great Salt Bay and loved Damariscotta Lake, built fire trucks in his welding shop, which was previously known as the Red Men's Hall. They were sold to local towns in Maine. The one pictured above was sold to the Bucksport Fire Company in 1952. Hollis also played his saxophone at many dances in the area and had a seaplane on Damariscotta Lake. (Newcastle Historical Society Dinsmore-Flye Collection.)

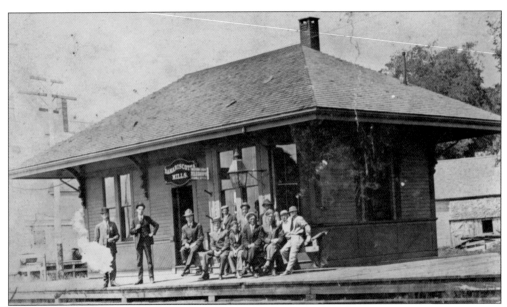

In this photograph of the Damariscotta Mills railroad station from the 1920s, a group of local men are waiting for a train. The man standing second from the left is believed to be the stationmaster, Arthur White. Sitting to White's immediate right is Fred Pinkham. The man at the center of the first row in the dark suit is Jim Dalton, who was a selectman and member of Red Men's Order. Next to Dalton on the right is Melrose Jones. (Robert Wheeler.)

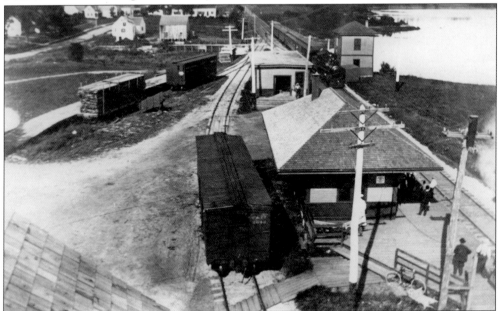

The Damariscotta Mills railroad station and square water tower were important community landmarks in the early 1900s. The steam engines needed fresh water, so a gravity-feed system was constructed from the millpond around 400 yards down the hill to the water tower. In the 1940s, when the railroad station closed, local residents formed a water association and connected extensions from existing iron pipes to about 30 homes. This system still exists. (Nobleboro Historical Society.)

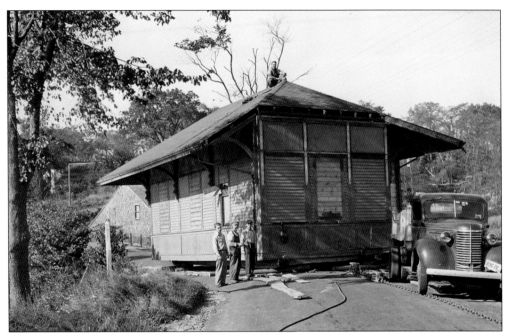

After the Damariscotta Mills railroad station closed in the late 1940s, the building was raised onto a wooden frame over rollers and pulled to Newcastle using a Ford truck. As the building moved forward, the rollers that were no longer used in the rear were moved to the front of the building. Moving a building was a slow, tedious, and challenging job. (Newcastle Historical Society Dinsmore-Flye Collection.)

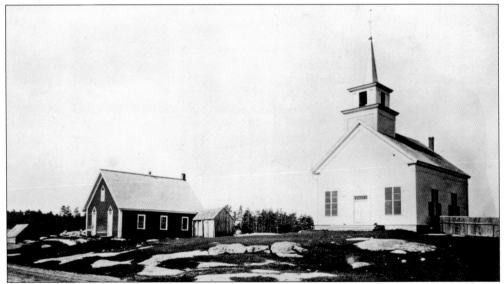

The Methodist church shown here was built in the 1850s in Damariscotta Mills. The congregation bought the land from Samuel Borland for $100 and the "right to choose his own pew" but struggled with membership and finances for over 100 years. It became a private residence in 1955. The red schoolhouse, built in 1842 on Borland Hill, was one of Nobleboro's 12 one-room schoolhouses in 1886. It was moved in 1899; resident John Weaver was killed during the hauling. (Nobleboro Historical Society.)

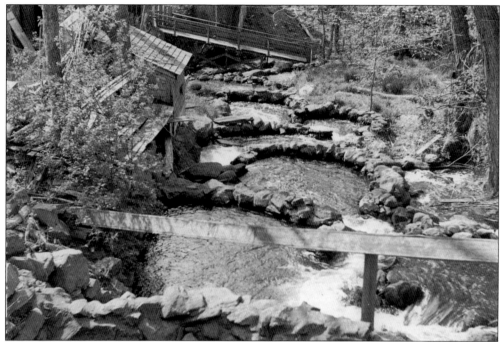

Every May for about a month, the Damariscotta Mills fish ladder is crowded with thousands of alewives trying to make it upstream to spawn in Damariscotta Lake. The alewives start their journey in the Atlantic Ocean and swim up the Damariscotta River and into Great Salt Bay to reach the fish ladder (eastern stream) and to ascend 42 feet to the millpond. The 1947 picture (above) looks downstream over a few of the jumps (weirs) and stone resting pools. The alewives that make it to the lake lay their eggs before returning to the ocean later in the summer. Alewives have been harvested at Damariscotta Mills since the early 1800s. The 100-foot-long fish plant (below) was opened in 1892 to process alewives by salting and pickling. The wooden structure leading to the plant is a spout (sluice) carrying alewives. (Above, Ivan Flye photograph from George Weston; below, Newcastle Historical Society Dinsmore-Flye Collection.)

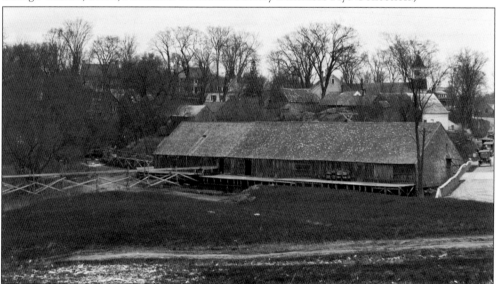

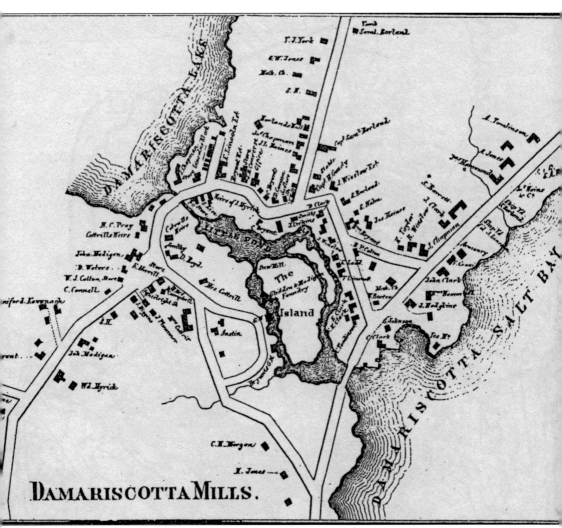

This 1813 map shows Damariscotta Mills, which is the area surrounding the south end of Damariscotta Lake, through the millpond (Little Pond), down the three streams, and under the bridge to (Great) Salt Bay. The waterpower created from the falls was harnessed to run the mills as early as 1730. There are three streams with the island in the middle. Mills and other water-powered structures were located on the larger western stream (furthest left) and the middle stream (right of the island, also called Mulligan Stream). Today, Central Maine Power uses the falling water to produce electricity. The eastern stream (right) is the fish stream or fish way and is also called the Lock (Locke) Stream or the Sacred Stream because alewives cannot be removed from this stream. The fish ladder is in this stream, and it is the only way the fish can get to the lake, as the other streams are too steep. However, alewives can be harvested anywhere at the bottom of the western and middle streams. (Nobleboro Historical Society.)

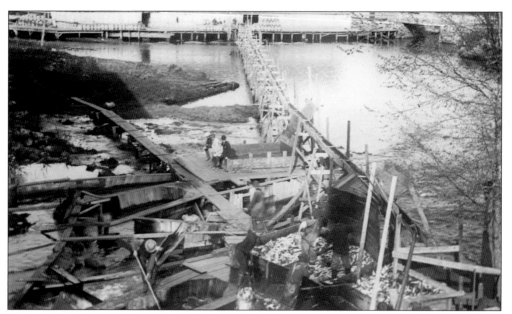

This 1918 photograph (above) shows the extensive wooden structure used to harvest alewives. It was constructed every spring from the far side of the western stream across the pond to the processing plant (top). As the alewives tried to migrate upstream, they swam into the closed-ended pens and the men shown in front scooped alewives with deep dip nets into large bins (center front). The fish were transferred from the bins into 300-foot-long, trough-like, water-filled spouts, which slanted toward the processing plant and were supported every 10 feet. Spring 1969 is the last time the structure was erected over the western stream. At the base of the middle stream, closer to the fish plant, there was a smaller harvesting structure, and Phil Winn (below) and another worker scooped alewives. (Above, Joseph Bernard Bryant photo from George Weston; below, Newcastle Historical Society Dinsmore-Flye Collection.)

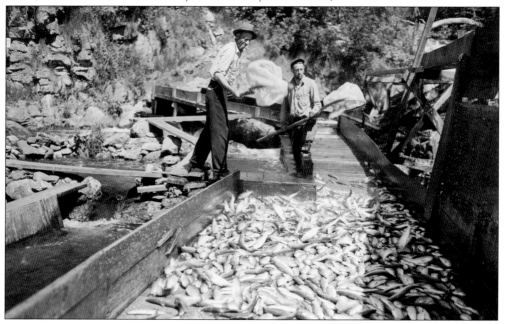

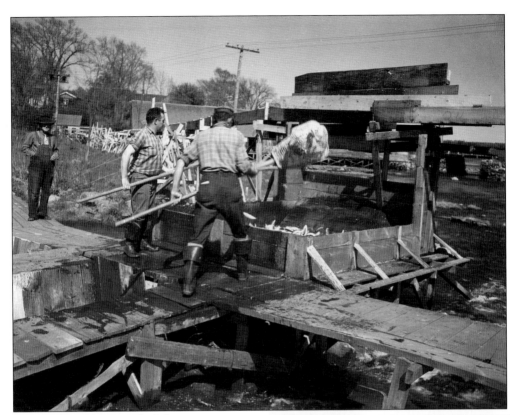

Frequently two men worked the same pen (above) and scooped the fish together to maximize the number of fish caught. It was better to be the man with the "back" net, as the first net contained a heavier load of fish. In the 1940s, Nelson Hancock designed and built mechanical metal dippers with electric hoists to do this job. Hancock's dippers are still used at the fish house. (Newcastle Historical Society Dinsmore-Flye Collection.)

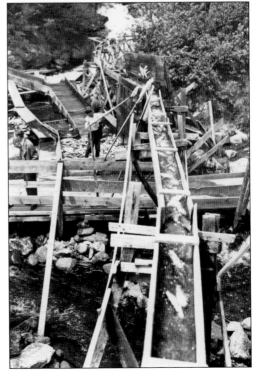

In 1947, the middle stream had a similar harvesting structure as the western stream. To get the fish from the bins to the plant, Harold Sidelinger bailed with a shallow net and tossed the alewives about seven feet up against boards, so they landed in the water-filled spouts. Each year after the alewives ran, all the wooden structures were dismantled and stored on the island. Photographer Ivan Flye stood to the left. (George Weston.)

The fish ladder was originally built in 1809 by John Perkins and Ephraim Rollins for $438. Since then it has been repaired many times. Two hundred years later, it is being completely restored through the efforts of the Damariscotta Mills Fish Ladder Restoration project, a joint project of the towns of Nobleboro and Newcastle and the Nobleboro Historical Society, to maintain the ecosystem and delight the public who travel to Damariscotta Mills every year to watch the running of the alewives and to see the bald eagles, ospreys, seals, and other animals that come to feed on the abundant fish. (Newcastle Historical Society Dinsmore-Flye Collection.)

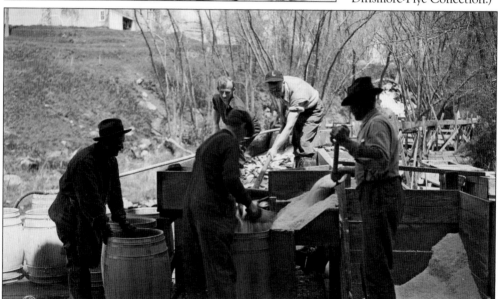

Salt was shoveled between the layers of alewives as the barrels were filled by, from left to right, (first row, in front) Glenn Rollins, Woodbury "Woodie" Oliver, and Bert Witham; (second row, on structure) Lawrence "Cy" Hagen and George N. Weston in 1937. After three weeks in storage, the alewives were removed, washed, and carefully repacked with layers of salt for shipping. Based on a 1800s ordinance, a portion of the annual alewife catch is still given to widows and the poor. (Newcastle Historical Society Dinsmore-Flye Collection.)

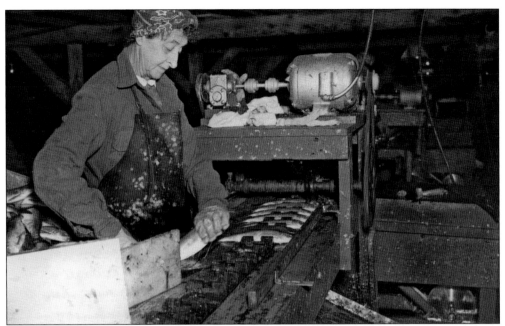

Alewife processing in 1947 included positioning the scaled fish on a conveyor belt, as done by worker Rosalie (Waltz) Witham (above), so a cutting blade removed the head and tail. Women then gutted and cleaned the fish by hand. A moving belt then carried the fish to a machine that filleted them. The young men (below) operated the machine that washed the fillets (back left). In the foreground, a machine processed heads, tails, carcasses, and other remains into bait and fertilizer. Men were paid 75¢ per hour, and women were paid 60¢ per hour. The plant closed in the late 1960s. Alewives were an important source of food for local areas, the West Indies, sailing ship crews, and later mostly foreign markets. In the 1930s, thousands of barrels of alewives were still packed each year, but human consumption decreased in the mid-1900s. Now alewives are used primarily for lobster bait. (Both, George Weston.)

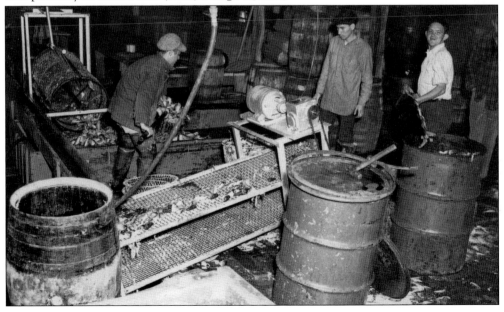

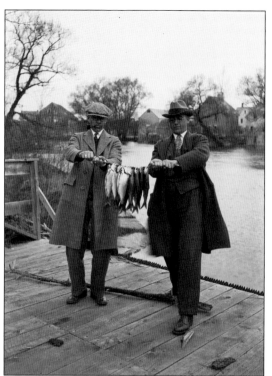

Alewives are an anadromous species of herring. They spend the majority of their life at sea and return to freshwater to spawn. They have slender bodies, grow to a length of around 10 inches, and weigh approximately eight ounces. Their backs are grayish-green, their bellies and sides are silver, and they have a single black spot above their eyes. Two Central Maine Power executives show off a nice string of smoked alewives in this 1940s photograph. (Newcastle Historical Society Dinsmore-Flye Collection.)

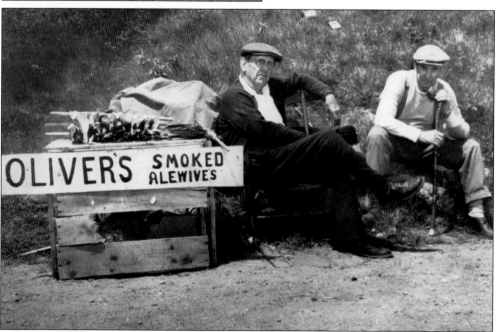

William "Willie" Oliver and Henry "Pat" Sidelinger sold smoked alewives at Damariscotta Mills. William sold to farm stores and individuals in Midcoast Maine and as far away as Waterville. William's brother Woodbury "Woody" Oliver owned several smokehouses and sold smoked alewives in the late 1920s and early 1930s. Woodbury was also the foreman at the fish packing plant. (Nobleboro Historical Society.)

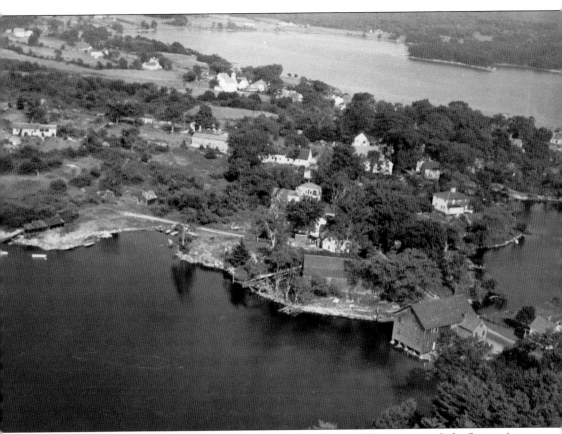

This aerial view from the late 1920s shows the end of the South Arm of Damariscotta Lake (bottom), Great Salt Bay (top), and the millpond (right). The millpond connects to the lake beneath the Head Gate Bridge, which is barely visible behind the large Red Men's Hall (lower right). The millstreams are not shown, but they were located to the far right. The Head Gate Bridge connects Nobleboro to Newcastle and is where steamboats and delivery boats docked and where children still swim in the summer. To the left of Red Men's Hall was Melville Ice House. Gundalow Cove can be seen curving along Lincoln Street (white line) to the Lester Hall sawmill. For fresh water, the residents went to a well at the end of Lincoln Street, almost to the sawmill. The Methodist church is toward the upper left corner. The cupola on the white Longfellow School appears in the middle of the Great Salt Bay shoreline. (Nobleboro Historical Society.)

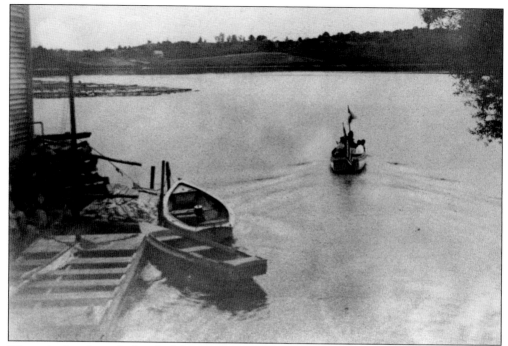

"Excursionists from the head of the pond in Jefferson on Monday evening took supper at Mr. Hahn's. They came down the lake on the small steamer *Lizzie Bell*," stated the *Lincoln County News* on August 28, 1879. Travelers Home, established close to the Head Gate Bridge on Damariscotta Lake in 1853 by the Hahn family, was one of about a half dozen hotels in Damariscotta Mills that catered to both visitors and workers. (Arthur Jones.)

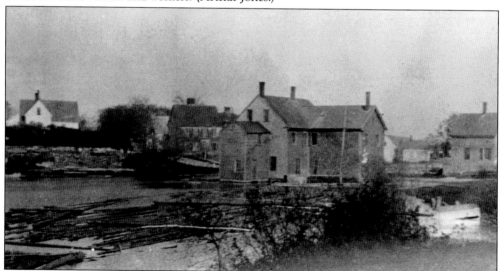

Joshua Linscott bought land in Damariscotta Mills from Kavanagh and Cottrill in 1825 for $326. He then sold the land and a building to Samuel and George Rollins for $1,900. In 1856, Joseph Haines purchased the property to use as a store; and in 1890, James Mulligan bought the property after his store across the street burned. Massasoit Tribe No. 68 made it the Red Men's Hall in 1918. In 1943, Hollis Nelson bought the property for $200. Recently it was restored as a residence. (Arthur Jones.)

"The Chiefs of Massasoit Tribe Imp. ORM were raised up at their new hall last Saturday evening by District Deputy Grand Sachem James E. Dalton," was the lead sentence in the *Lincoln County News* in August 1920, after the Red Men's Order purchased the building at the Head Gate Bridge. Jim Dalton, in costume, presided at meetings holding a tomahawk and spear. The nationwide patriotic group, Improved Order of Red Men, was a men's social organization formed to honor the values and ways of the Indians who originally lived in New England, especially the real freedom of the "wild savages." Freedom, friendship, and charity were their mottos, and Old Glory was their emblem. Below, Fred Smithwick (in suit and tie) was initiated into the order. The same *Lincoln County News* article notes that on North Star Island "they perform much of their ritualistic work and the warm and beautiful moonlit evening frequently resound with the war whoop and the yells of triumph as the captured pale faces are made Red Men." (Right, Nobleboro Historical Society; below, Joyce Ball Brown.)

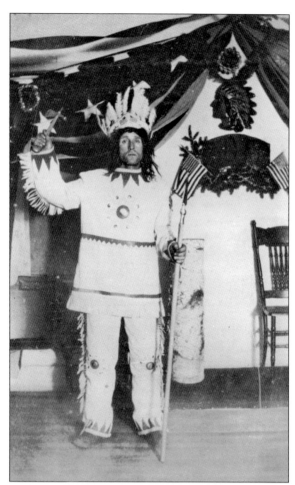

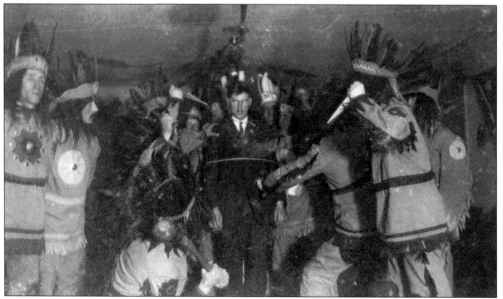

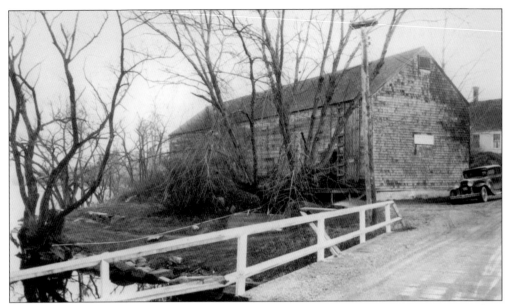

George "Harry" Melville built his icehouse at the Head Gate Bridge in Damariscotta Mills in 1927. After Melville married Alice Jones from Damariscotta, the icehouse became part of Jones Coal, Wood & Ice Company, which was owned by Alice Jones's father. The icehouse provided ice until 1959. Packed in sawdust for insulation, the ice had to be washed with water from the lake before delivery. A thin, white waterline drew water from the lake. In 1972, the site became Ice House Park and is open for swimming during the summer. (Arthur Jones.)

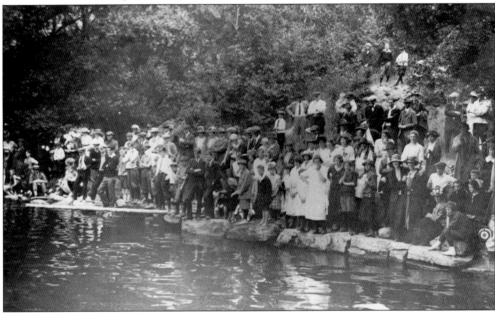

People gathered at Gundalow Cove near the Head Gate Bridge for a Fourth of July celebration. Part of the fun was watching children as they tried to walk to the end of a greased pole (white line center left). A dollar bill was attached to the tip of the pole. If the child could reach the end of the pole and return to the shore without falling in the water, the dollar bill was his to keep. Isaac Buzzell was in charge of the pole. (Robert Wheeler.)

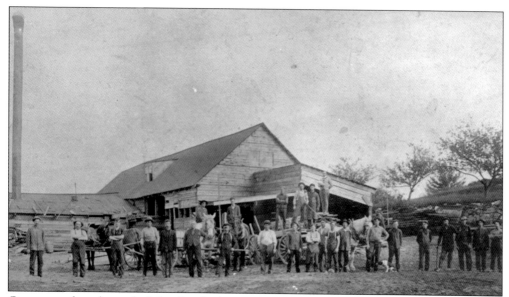

Constructed at the end of the South Arm in Damariscotta Mills near Gundalow Cove in 1909, the Frank H. Robinson & Perly R. Eaton sawmill used a steam boiler for power instead of waterwheels; it burned July 3, 1912. Notice how young some of the workers appear. After the first sawmill burned, the Lester Hall sawmill was built on the same site, where it produced lumber from 1924 to 1945. Pictured here is William Hale (second from left), who was the in charge of the leatherboard factory construction project in 1906. (George Weston.)

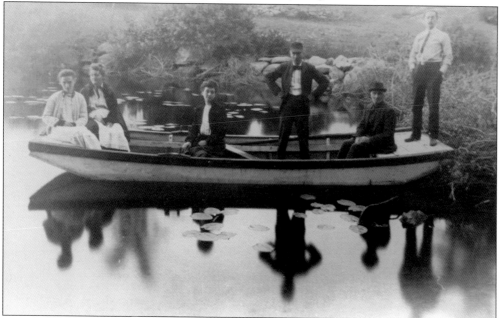

This photograph from 1900 shows a family enjoying a boat ride in Gundalow Cove near Lester Hall's sawmill. From left to right appear Grace Littlefield, Carrie Jones Littlefield, Ethel Littlefield, Frank Jones, Kiah Jones (father of Carrie and Frank; great-grandfather of Arthur Jones, who helped with this book), and John Littlefield (Carrie's husband). John Littlefield was a well-known professional photographer, and he probably posed this photograph. (Arthur Jones.)

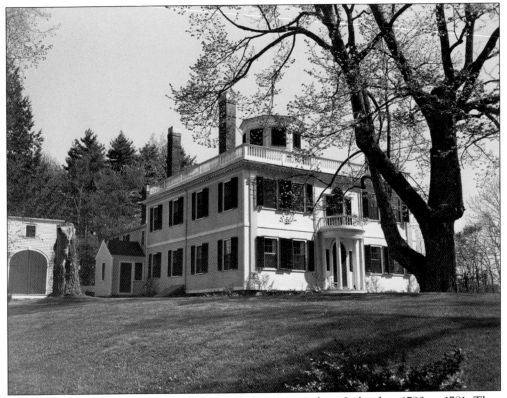

James Kavanagh and Matthew Cottrill arrived in Boston from Ireland in 1780 or 1781. They heard stories of waterpower, timber, and shipbuilding in Newcastle, and in 1801, they opened a mercantile business in Damariscotta Mills. Making tremendous profits from trading with the West Indies, both were able to build beautiful mansions. The Kavanagh home, built on Damariscotta Lake in 1803, still stands today. (Newcastle Historical Society Dinsmore-Flye Collection.)

Before coming to Newcastle, James Kavanagh married Sarah Jackson in Boston in 1794. Together in Damariscotta Mills, they had seven children. Their eldest child, Edward Kavanagh, became the governor of Maine in 1842. It is rumored that Kavanagh and Matthew Cottrill shanghaied an architect to design their homes in the early years of 1800. Kavanagh's home displayed eloquent, bold woodwork, which matched his personality. (Newcastle Historical Society Dinsmore-Flye Collection.)

James Kavanagh and his business partner, Mathew Cottrill, cut the trees from their own property, utilized their two sawmills at Damariscotta Mills, and built ships to carry lumber to the West Indies. The lumber was also used by local citizens to build homes. They built approximately 25 ships, including the *Hibernia*, which was constructed in 1798 or 1799. (Newcastle Historical Society Dinsmore-Flye Collection.)

In 1946, writers Jean Stafford and Robert Lowell bought this Damariscotta Mills home, which was built in 1820. During the couple's time there, Lowell wrote *Lord Weary's Castle*, for which he received a Pulitzer Prize, and *The Mills of the Kavanaughs*. Stafford penned the short story "An Influx of Poets," which appeared in her Pulitzer Prize–winning *Collected Stories of Jean Stafford*. (Ellen Welsh.)

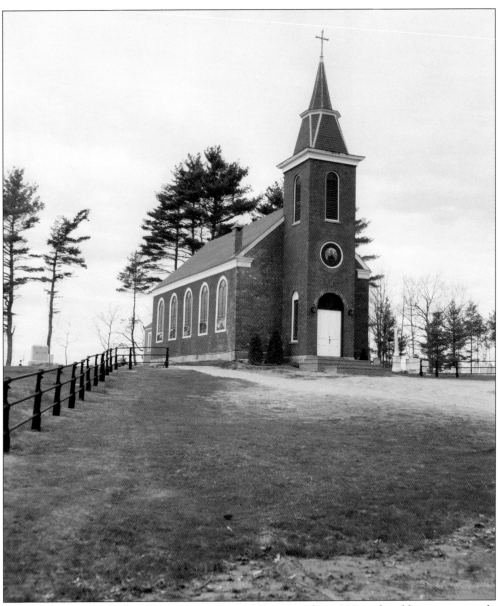

St. Patrick's Catholic Church at Damariscotta Mills, erected in 1808, is the oldest continuously used Catholic Church in New England. It was the philanthropic project of James Kavanagh and Matthew Cottrill. Architect Nicolas Codd designed this Federal-style church. The walls were built of odd-shaped bricks, which were made on the other side of Damariscotta Lake and hauled by oxen across the ice during the winter of 1807. The limestone was imported from Ireland and made into mortar at the church. Originally, the church had plain, small-paneled windows with shutters on the outside and backless plank benches as pews. The only amenities were the benches and the wood stove. In 1896, the plain windows and shutters were replaced by stained glass windows, the benches were replaced by pews, and the white ceiling and walls were elaborately decorated. Cottrill is credited with acquiring one of the last bells cast by Paul Revere, which is housed in the tower. The church is on the National Register of Historic Places. (Newcastle Historical Society Dinsmore-Flye Collection.)

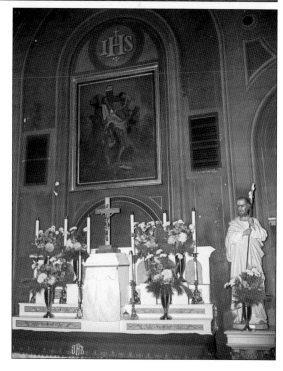

The altar inside St. Patrick's Catholic Church is older than the church itself. It is built in the form of a tomb, similar to the one in the crypt of the Holy Cross Cathedral in Boston. It may have been imported from France. The painting above the altar, *The Taking of Our Lord Down From the Cross*, was painted by an unknown artist but is definitely from France. The heraldic symbol of Ireland, the harp, is displayed on the doors on both sides of the altar. There are 14 small wooden stations of the cross above the windows and doors. They were installed in 1876 with titles in French, Spanish, and English. These photographs were taken in 1959. (Both, Newcastle Historical Society Dinsmore-Flye Collection.)

At Eldon Hunt's camp on Damariscotta Lake in Newcastle, these campers from New Jersey were set up to fish and enjoy nature. Hunt had a farm nearby on Bunker Hill Road. Every farmer along the lake had what was known as a pond parcel. Many farmers sold their parcels to people to build camps. Most pond parcels were eventually fenced off so livestock could no longer drink from Damariscotta Lake. The Hunt Homestead was once part of the town of Jefferson. Agriculture on the lake mixed commercial endeavors with subsistence farming. Vegetable gardens, livestock, and timber harvesting were for personal and commercial use. (Both, Newcastle Historical Society Dinsmore-Flye Collection.)

The privately owned Pond Road Community Club in Newcastle was a gathering place for people living around Damariscotta Lake. People played cards and exchanged recipes, stories, and family news. In this photograph, Eddie Lincoln and others gathered for a wood bee, which was held so that slab wood, which are pieces left when one squares up a log, could be stacked in the shed. The building was the former Pond Road School House. Today, it is a storage facility for Don Hunt. (Newcastle Historical Society Dinsmore-Flye Collection.)

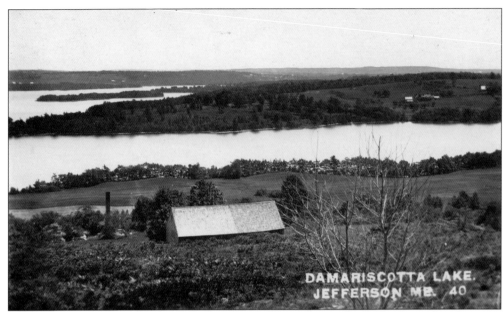

This early view from the Bunker Hill Church in Jefferson during the 1900s shows that the water level was lower than it is now. The view today, however, is still spectacular and is preserved through a conservation easement. Many farms rimmed both sides of Bunker Hill Road. The Bunker Hill Baptist Church began in 1808 as the Second Baptist Church, meeting in barns and schoolhouses in South Jefferson. Owned by C.C. Linscott, the Hillside Farm on Bunker Hill Road offered double rooms. If two people stayed in a room, they were each charged $7; if only one person stayed in a room, he was charged $9. The price included "a table amply supplied with the products of the farm and plenty of fresh eggs, cream, and berries in their season. Pure spring water and daily mail delivered." Motorboats and rowboats were offered for a small fee. Transportation was provided to and from the trains at Damariscotta Mills. (Both, Ralph Bond.)

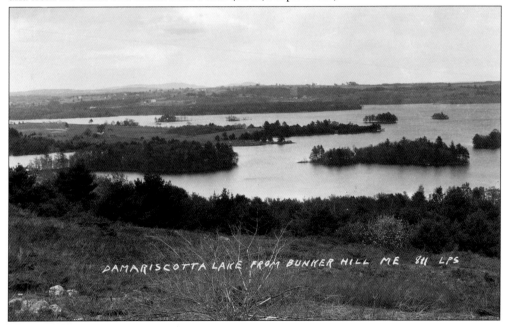

The Second Baptist Church divided in 1824. One group built the Trask Meeting House and the remaining congregation met elsewhere until Belinda Linscott Bryant donated a half-acre parcel of Linscott family land in Jefferson to the church in 1889. The church building was dedicated on January 14, 1890. The steeple was originally built in the middle of the church roof, but the heavy bell required that the present tower be constructed. (Newcastle Historical Society Dinsmore-Flye Collection.)

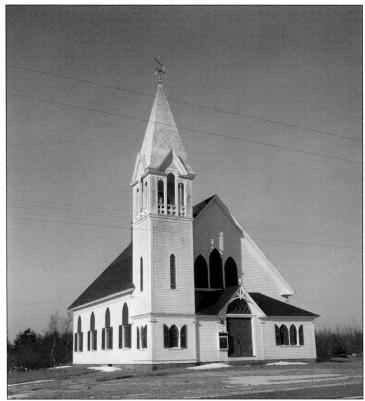

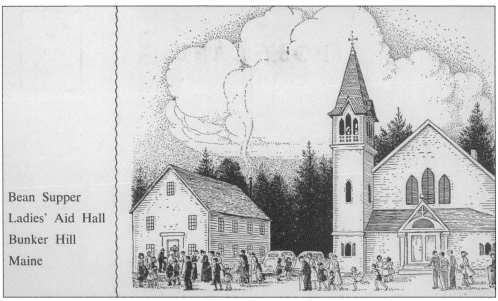

Bean Supper
Ladies' Aid Hall
Bunker Hill
Maine

The Ladies Aid Society was organized in 1891 to support the church and community and to raise money for a social hall. Suppers were held in homes to raise a few dollars at a time. Completed in 1912, the social hall became the center of a very active community with public suppers and activities. The Bunker Hill Grange also used the hall for its meetings and events. (Jefferson Historical Society.)

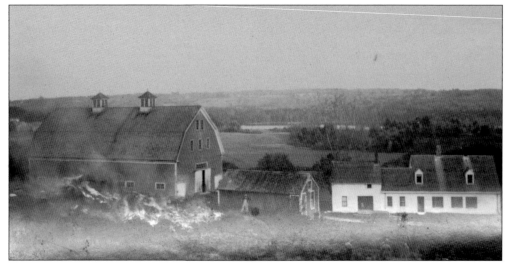

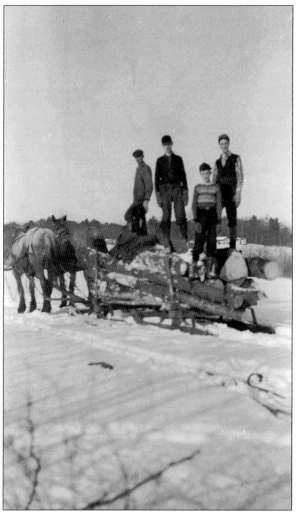

Orla and Mildred Johnston and three of their sons, Leon, Richard, and Erland, bought Charles Weeks's 600-acre farm in Jefferson in 1939. They rejuvenated and enlarged the orchard; fixed up the buildings, including the 100-foot long barn (the largest in Lincoln County); and cleared the land. The family always had a team of horses for the utility wagons, carriages, and sleighs. They sold firewood, apples, cider, and vegetables; raised Hereford cattle; hayed to feed the animals; and excavated and hauled gravel. Leon later moved to a farm in Jefferson. Erland and Richard continued at Deer Meadow Farm as Johnston Brothers and developed a 45-year paving business. The photograph above from 1939 shows several piles of brush burning above the house. At left, Orla drives the team with, from left to right, Leon, Richard, and Erland standing on top of the piled logs. (Both, Johnston family.)

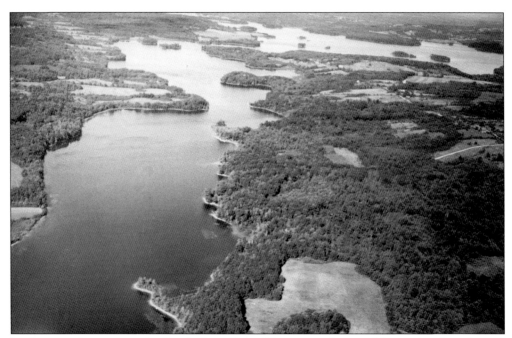

Looking northeast along the South Arm, Camp Kieve is on the tip of the peninsula at the end of West Neck Road (white line). Several small farms are visible on both sides of the lake and the cleared area at the bottom was probably Ruth Erskine's farm, which was located just north of J. George Birkett's farm. By the 1940s, the trees have grown back after being cut down for the mills. (Nobleboro Historical Society.)

In 1941, J. George and Doris Birkett purchased a farm in Nobleboro from Everett Chapman, whose family had lived on the land for generations. Birkett raised hay, sweet corn, peas, beef cattle, pigs, chickens, and goats. Son Jim said, "But was it a true working farm? I doubt if it ever ran in the black. Pop also worked part-time for the Maine Breeding Cooperative, going around Knox and Lincoln Counties artificially inseminating cattle." (J. George Birkett.)

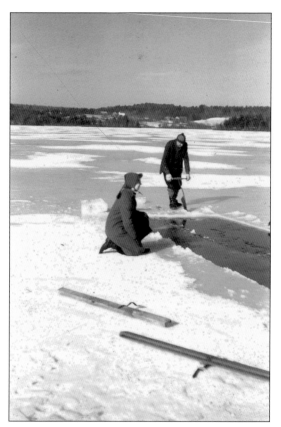

Doris Birkett and George Hodgkins of West Neck sawed sections of ice in about 1945. Since the 1700s, ice was cut on the lake, stored, and used to keep food cool. When the ice was about 12–15 inches thick, it was scored into blocks with a saw. If the ice was too thick, the blocks became too heavy to handle. Using a long-handled wedge, the blocks were broken off and floated to the edge of the open water. The ice block was grasped with large, iron ice tongs, pulled out of the water, and then hauled up the hill to an icehouse that was fairly close by. (Both, J. George Birkett.)

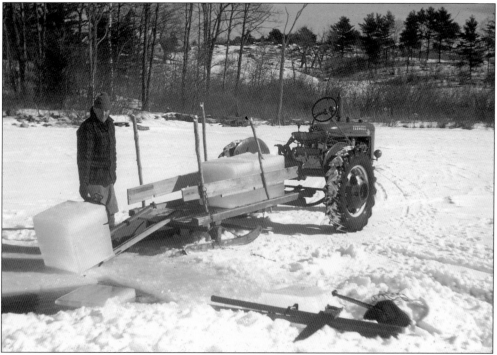

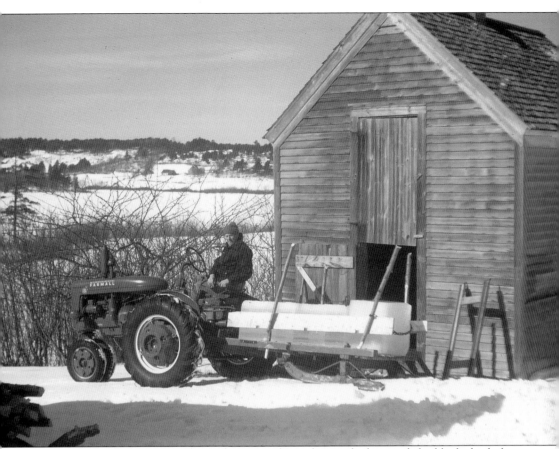

Ice was stacked tightly into wooden icehouses with sawdust packed around the blocks both for insulation and so blocks could be separated when needed. Ice usually lasted until midsummer, or longer as long as the lower levels of the icehouse were dug deep into the ground. Larger icehouses had ramps leading directly into them, sometimes with a motorized conveyor belt. Maine ice, especially from the Kennebec River, was delivered along the East Coast of the United States and went as far as India to cool the drinks of the English. In kitchens of this era, blocks of ice were put into iceboxes. Iceboxes were insulated cabinets used to keep foods cold. They had a drain to collect the melted water. In towns, icemen delivered ice blocks to homes daily, and children delighted in sneaking small ice chips off the wagon. World War II stalled rural electrification because all the copper went into the war effort; nonetheless, electrical power arrived on West Neck Road in about 1947, allowing families to purchase refrigerators. (J. George Birkett.)

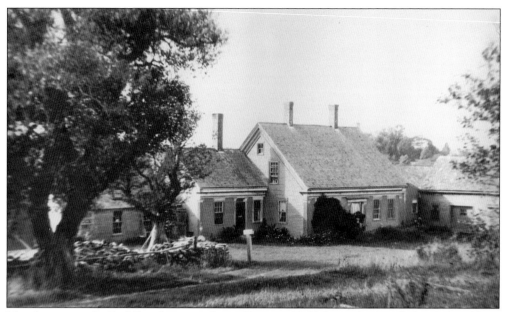

Now known as the Red Farmhouse at Camp Kieve in Nobleboro, the Hatch family lived here starting in 1790. Around 1900, Jim Hatch lived in the right side of the house. He advertised for a bride and married Hattie Cook in 1913 when she arrived with her daughter Ruth. Ruth married Osmund Erskine in 1919 and moved down the road. In the 1920s, Fred Hatch III lived in the left half of the house. Problems arose between Jim and Hattie and Jim left, never to return. In 1926, Hattie sold her half of the house and a section of the peninsula to Donald Kennedy (below), a Philadelphia teacher who wanted to start a summer camp for boys. Fred Hatch married Eola Jackson Jones in 1929 and she moved in with two of her children, Arthur and Mellicent. After living in the house for about 20 years, Fred and Eola sold their share of the property to Kennedy. (Both, Henry Kennedy.)

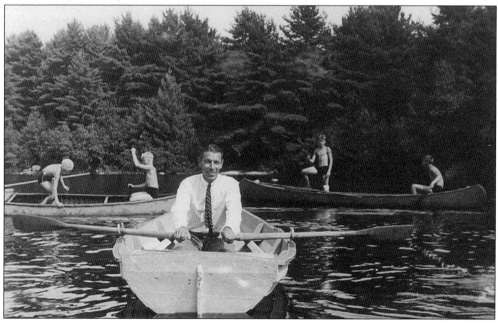

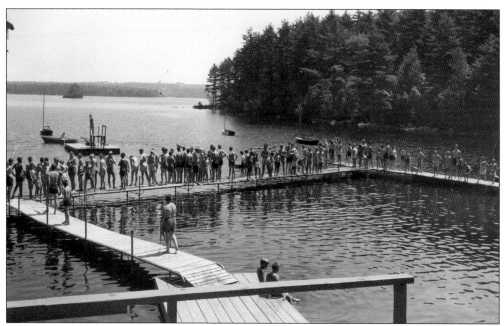

Don Kennedy founded Camp Kieve for Boys as a small camp in 1926. It soon served many boys, including the sons of prestigious families like the Rockefellers. Over 500 boys still flock back every summer. "The focus then was a reflection of the times, as it was primarily athletic and competitive in nature. Our orientation today is preparing young people to be contributors to society," stated Richard Kennedy, son of the camp's founder. Below, Kieve boys return to their cabins to write the obligatory letter home. The word *kieve* means "to strive in emulation of." Then, as now, the counselors acted as role models for younger boys to emulate. The current CEO, Henry Kennedy, is the grandson of the founder. (Both, Kieve-Wavus Education, Inc.)

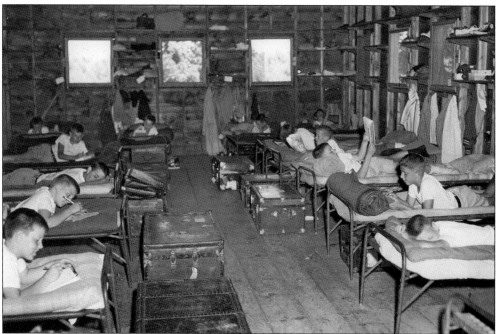

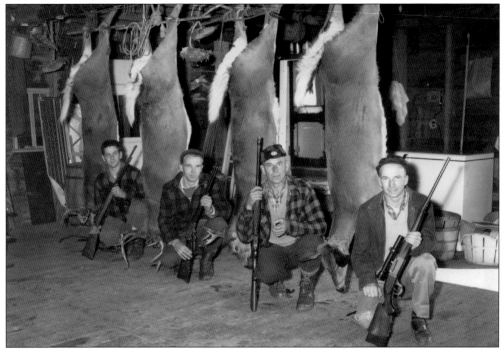

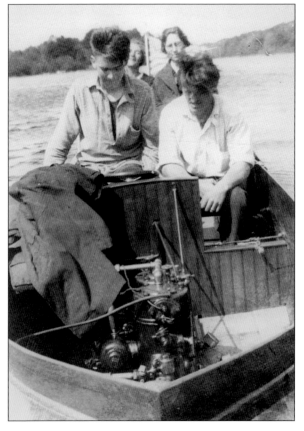

This photograph shows the scene of a successful hunting trip for the Weston family in November 1951. The trip, which took place in the woods near the top of the lake, resulted in large deer for, from left to right, Donald E. Weston Jr., Lawrence E. Weston, George B. Weston, and George N. Weston, who shot a doe. George N. Weston, who helped with this book, graduated from the University of Maine at Orono; he had a distinguished and meritorious career in navigational science in Washington, DC. (George Weston.)

Jim Mulligan (left) and Melrose Jones sat on the front bench seat, and their wives, Myra Mulligan (left) and Eola Jones, sat in back. The early motorboats of 1917 were simple designs, some with the engine in front. A steering wheel controlled the drive shaft, which typically ran the length of the boat to turn the propeller in back. (Arthur Jones.)

Two

MUSCONGUS BAY

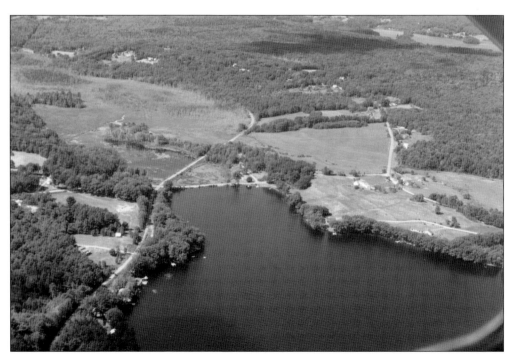

This aerial photograph from 1994 shows how rural the south end of Muscongus Bay appears. In 1821, the area had a bit more activity. That year, 19 respected townsmen formed Damariscotta Canal Incorporated with the plan to dig a four-mile canal by hand from Vannah Road on Muscongus Bay to Great Salt Bay to circumvent the high fees charged at Damariscotta Mills. Due to deep bog and ledge, the project was abandoned in 1834 after two miles had been dug. (Michael Ball.)

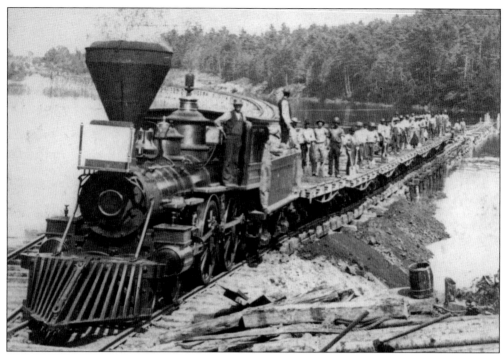

From 1869 to 1871, William Vannah and his workers built seven miles of track for Knox & Lincoln Railroad along a boggy and unstable part of Muscongus Bay. The track crossed Vannah Road and would service the sawmill, rock crusher, and gravel pits on the way to Damariscotta Mills. Workers were paid 29¢ for each cubic yard of fill they moved using single-horse carts. The carts could only hold half a cubic yard, and the work was difficult. (Nobleboro Historical Society.)

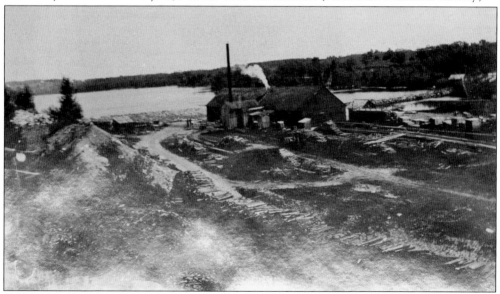

When steam power became available in the early 1900s, George Pastorious built a large sawmill on Muscongus Bay over Vannah Road at the railroad junction near East Neck Road. In the 1920s, Joe Chaput took over the mill and operated it until 1943. With the railroad right there, lumber could be loaded on freight cars bound for Portland or Boston. (Thomas Moody.)

The steam rising from the sawmill was produced by burning slab wood and waste sawdust. Logs cut alongside the lake were hauled to the water and rafted to the mill. In the winter, the logs stayed on the ice until spring. Otis Oliver operated a scow to carry logs and lumber on the lake. Logs were then hauled by tow chains over Vannah Road, which was planked to prevent dirt-caked logs from dulling the saws. (George Weston.)

When US Route 1 was being rebuilt in the 1930s, W. Hinman started a rock-crushing plant behind the sawmill site on Muscongus Bay. Rock was available locally from gravel pits located on both sides of Vannah Road toward East Neck Road, but rock also arrived by railroad. After the local highway was completed, the rock-crushing machinery was moved to another site closer to the continuing work. (George Weston.)

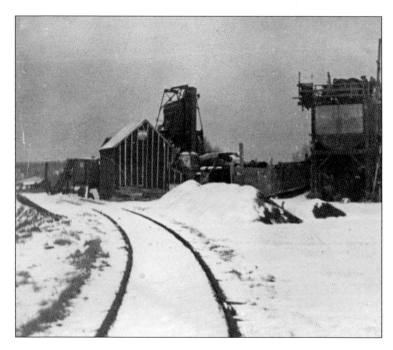

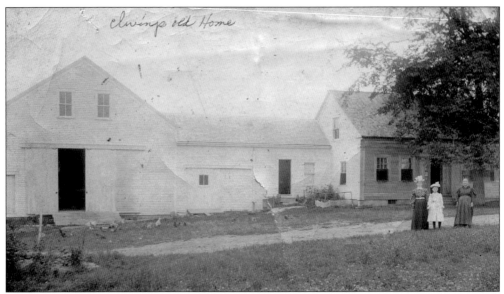

Patriarch Jonathan Oliver (1752–1837) settled in Nobleboro after serving in the Revolutionary War. In the 1800s, Jonathan Oliver III moved his farmhouse (above) across the ice from Snaggerty Road to East Neck Road using 30 oxen. Elwell and Florence Oliver (fourth generation) were married and lived in this house. Shown in the photograph from around 1906, the older woman (right) talking with dressed-up visitors was probably Lydia Oliver, wife of Edwin Oliver. Lydia and Edwin lived across the road, overlooking the lake. In addition to dairying, Irving Oliver (fifth generation) sold eggs and sauerkraut. When dairying regulations changed, Irving took jobs outside the farm to keep the farm going. Henry and JoAnn Oliver, the sixth generation, live on the farm today. The main house burned in 1969 and was rebuilt. The ell and barn are original. Henry kept a few cows for the family and milked by hand in 1978 (below). He also manages several wood lots. The tradition of working many jobs to stay on the farm continues. (Both, JoAnn and Henry Oliver.)

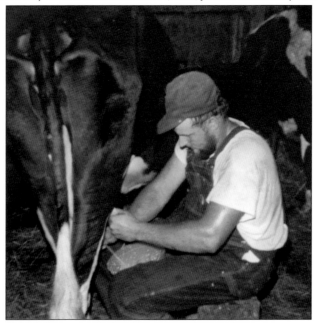

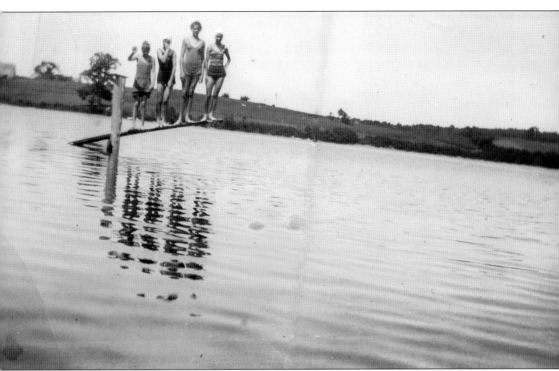

During the summer of 1932, young swimmers posed on the board at the sandbar in Muscongus Bay, not far from Vannah Road and Joe Chaput's sawmill. Elaine (second from left) and Willa Winchenbauch (third from left) were visiting their Rollins grandparents. In the background on the west shore of Muscongus Bay (left) is the farmhouse Jonathan Oliver II built in the early 1800s (currently owned by B.W. Flanagan). The Rollins' farm can be seen as part of the background to the right; their farmhouse was several hundred yards north. Originally part of Ephriam Hall's farm that was divided in 1857, the Rollins' farmland extended across the neck from Muscongus Bay to Deep Cove almost at the end of East Neck Road overlooking Muscongus Bay. The family names changed for this farm as it was passed down through two generations of Halls and then the Rollins, Winchenbauch, and Stevens daughters. There have been farmhouses along this shore since the 1700s. (Marc Stevens.)

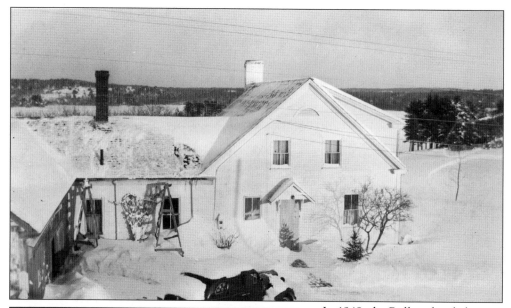

In 1948, the Rollins family home (above) was basically unchanged from the old farmhouse of the 1800s, except for the dormer that was added in 1946. Agnes "Aggie" Hall Rollins and Otis Howard Rollins stood in front of the farmhouse in 1936 (left). Willa Winchenbauch Stevens, an active member of the Nobleboro Historical Society, occupied this house until 2008. In the 1990s, Marc Stevens—the sixth generation to own the land—started Ledgewood Red Deer Farm. He raised red deer for their antlers on the property for some time. The powdered antlers are said to possess medical benefits. Marc and his wife, Patricia, who live up the road, are restoring the farmhouse and will eventually live there. (Both, Marc Stevens.)

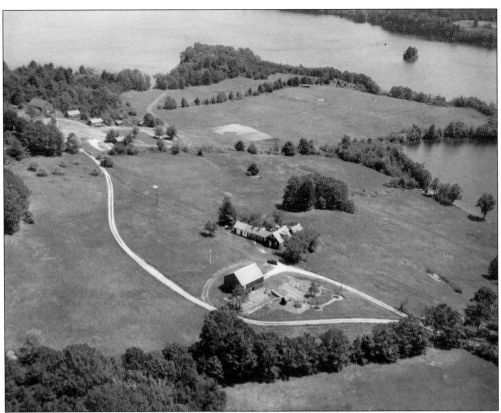

In the early 1800s, Ephriam, the son of Daniel Hall, lived at Chimney Farm. In the late 1800s, William B. Hall had a fine apple orchard there and offered 18 varieties, which were sold locally and stored until midwinter when apple buyers made their rounds of the farms. Current farm caretakers Gary Lawless and Beth Leonard are working to restore the old apple varieties. (Gary Lawless.)

Henry Beston, author of *The Outermost House* and *Northern Farm*, and his wife, Elizabeth Coatsworth, author of more than 135 books for children and adults, moved to Chimney Farm in 1935. *Northern Farm* described rural life in Nobleboro in the mid-1900s. Henry had two daughters; one, Kate Beston Barnes, became Maine's first poet laureate. But Henry wanted a namesake and asked pregnant women if they would name their son Henry. At least two local residents were named Henry after Henry Beston. (Gary Lawless.)

Still located at the end of East Neck Road on the west side of Muscongus Bay, the James Hall house was built in 1791. However, sometime between 1803 and 1815, it was moved about a mile across the frozen lake and up the steep hill to this site. Somehow, the huge central chimney and Dutch oven were not damaged. Hall's son Daniel (1779–1855) bought the house and property and lived there with his wife, Mary Genthner Hall. (Grayce Hall Studley.)

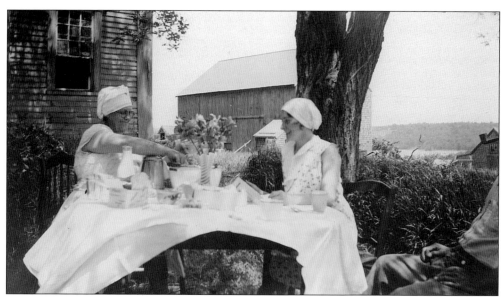

In 1933, Estelle Smith Hall (1900–1996) and her aunt Luella Genthner Morang (left) took a break from opening the house for the summer. Estelle's husband, F. Clive Hall (1898–1986, only lower body is visible in the right corner), enjoyed the white tablecloth and lovely table setting under the tree as well. New siding had just been put on the house. Estelle and Clive's daughter Grayce now lives in the house with her husband, John Studley. (Grayce Hall Studley.)

On the long slope from the house to the lake, Estelle Hall established and directed Camp Makaria for Girls from 1935 until the late 1940s. The camp catalog said the girls would "find happiness and contentment . . . free from the strict routine of the school year." Activities included swimming, boating, horseback riding, tennis, music, and drama. The cabins were restored and are now operated as rental units by Grayce and John Studley. The Hall family made important contributions in Nobleboro and beyond. James was a master carpenter and shipwright in the 1700s and the "only man capable of launching a vessel" at Shank's Point. Daniel Hall had 11 children, and 20 of his grandsons served in the Civil War. Grandson Thomas G. Hall (1833–1863) was a master's mate aboard the gunboat Diana. He was killed in action while fighting Confederate forces on Bayou Teche in Louisiana. Grayce Hall Studley taught in Massachusetts and was the director of the English as a Second Language School in Portland until 2005. (Grayce Hall Studley.)

John Werner (Vannah) was the first to come to Maine from Germany. In 1803, son Charles Vannah built a new house on the commanding hill in Nobleboro on the east side of Muscongus Bay. William Vannah (1830–1921) was a farmer, but he also built a one-room schoolhouse, captained the *Queen of the Lake* steamboat from Jefferson to Muscongus, and built seven miles of track for the Knox & Lincoln Railroad along the lake behind his farm. (Eleanor O'Donnell.)

Hudson Vannah (fifth generation) was William's grandson. He was born in 1907 and was always a farmer at heart. As a young man, Hudson raised prize-winning chickens and worked on the dairy farm. His poultry business grew to a capacity of over 1,000 eggs. He sold eggs, hatching eggs, baby chicks, replacement pullets, and chicken for eating. Like other farmers, Hudson worked outside of the farm as well. (Eleanor O'Donnell.)

The view north from the Vannah farm over Muscongus Bay remains basically unchanged. The railroad track (dark area across middle), built by hand in 1870, had to be raised above the unstable shore. Changing markets for farm products required flexibility. When poultry farmers started raising thousands of birds under one roof, Hudson Vannah could not compete, so he switched to turkeys in the 1970s. Dairy farming changed when electricity arrived in the mid-1930s. Before electricity, farmers milked by hand and poured the milk into five-gallon cans to be cooled over ice. Ice was dug out of the sawdust, washed, and put in the milk tank every day. Electric milking machines and coolers replaced the old techniques. When strict state regulations made dairying too expensive, Vannah began raising Charolais cattle for beef. He worked outside of his farm as road commissioner for 25 years and foreman on state-financed local construction projects. Like other local farmers, Vannah and his family before him worked many jobs to keep the farm. Vannah mowed the fields himself using his tractor until shortly before his death at age 100. (Eleanor O'Donnell.)

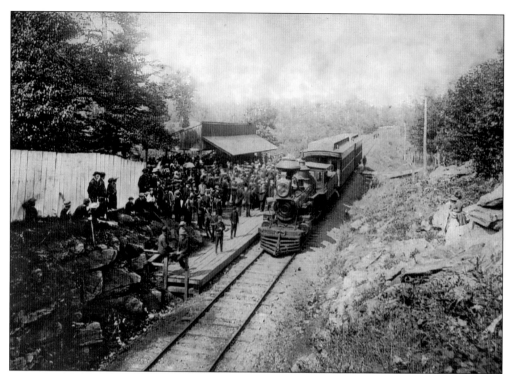

The Methodist Camp Meeting just east of the lake at Glendon started in 1872 and closed in 1908. This large meeting was held on a nine-acre parcel in Nobleboro purchased from Daniel Benner. At times, the Knox & Lincoln Railroad had 12 daily trains stopping at Glendon Station. These meetings were initiated and run by the Rockland District Camp Meeting Association of the Methodist Episcopal Church. The meetings were held during the first week of September from Monday until Saturday. Admission, which was 10¢ for the whole week, covered program costs and eliminated the need for collections during services. In 1877, an estimated 7,000 people were reported on the grounds and more buildings were needed for the crowds. This photograph from 1888 shows the two-story Lincoln Hotel three years after it was built. The dining room seated 250 at a time. The ell in back had a fine cooking arrangement for coal or wood. Every room had running water. (Both, photograph by J.C. Higgins and Son, Bath, Maine; courtesy George Weston.)

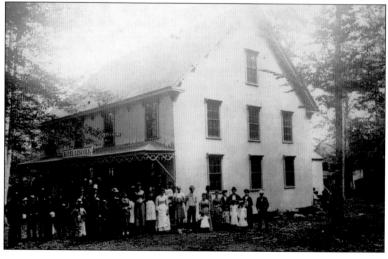

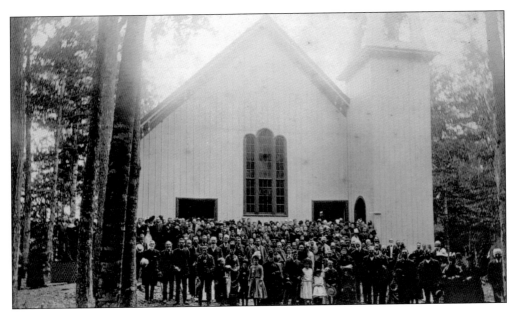

Temple Hall, built in 1888, could seat 1,000 people. It cost $2,600 and measured 80 feet by 50 feet. The hall had posts that stood 16 feet and a 50-foot tower that held a 300-pound bell. The adjacent outdoor seating area (below) was 50 feet by 72 feet and could seat 1,200–1,500 people. In addition to religious meetings, the hall hosted social activities, which were criticized for distracting from the religious purpose. In addition to the commercial and religious buildings, families like Daniel A. Benner's constructed substantial and attractive two-story residences. Visitors from long distances could take the train and the steam-powered boat the *Queen of the Lake*, which traveled regularly from the top of the lake and brought people to its dock at Muscongus Bay, only a short distance from the grove. Attendance at the camp meetings began to decline in 1890, and it closed in 1908 after 36 years. Buildings were dismantled or moved; the temple became the opera house in Port Clyde. (Both, photograph by J.C. Higgins and Son, Bath, Maine; courtesy George Weston.)

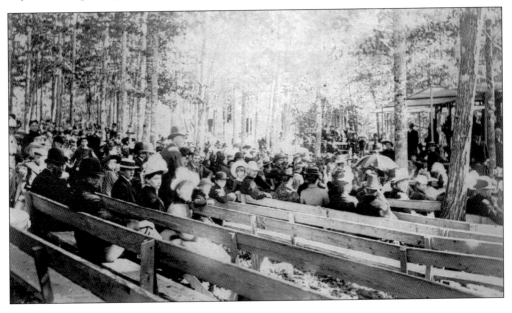

Wearing the stylish sportswear of 1917, Eola S. Jackson Jones posed among the trees on North Star Island. A small island in upper Muscongus Bay, North Star Island was claimed by squatter's rights. As teenagers and young men, Melrose Jones, Jim Dalton, Woodie Oliver, the Mulligan brothers, and others would go fishing and just hang out on various islands until they settled on North Star Island as their favorite for their adventures. Even the Order of the Red Men used the island. Over time, Jones became the only one who used the island. After he married Eola S. Jackson Jones, the family started a rough camp there in the 1920s. (Joyce Ball Brown.)

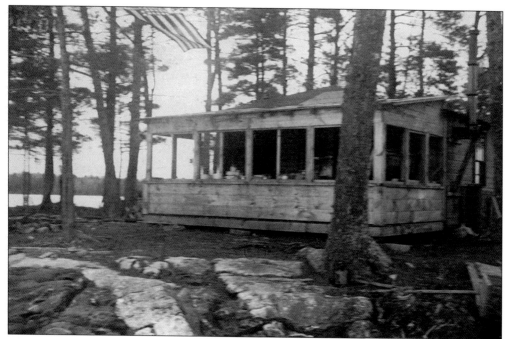

The Jones family improved the camp over the decades, and in the 1940s, it had an open porch that is now closed in. Finally, in the 1950s, the state approved the deed for the island. Now owned by Mellicent Jones Ball, there is still no electricity or running water, but the island has many productive high bush blueberry bushes. (Arthur Jones.)

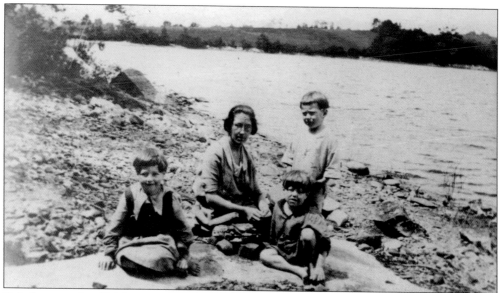

Eola Jones, wife of Melrose Jones, and her children, Mellicent Jones Ball (left), Arthur Jones (standing), and Ruth Jones Applin (sitting) had a picnic on the pebble beach of North Star Island in 1921. This beach is now under water because of the higher water level. (Joyce Ball Brown.)

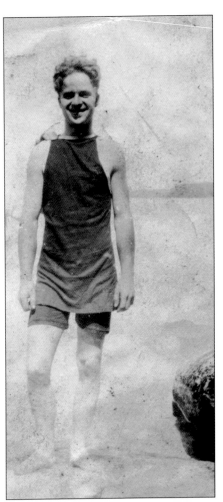

Fred Hatch III, shown wearing a stylish knit-wool swimsuit, was a guest on North Star Island in 1925. Hatch, who was born in 1900, served in World War I. According to the story, he had to stuff himself with bananas to weigh enough and lie about his age to be old enough to enlist. During World War II, Hatch manned a civilian radar unit in the lake to watch for enemy planes. (Joyce Ball Brown.)

This photograph from about 1890 looks west across the lake at Milliken's Island in Newcastle. One of the women in the canoe is probably Susan Jones (left), wife of Elijah Jones. The other is her sister-in-law Carrie, who was married to prominent photographer John Littlefield, likely the photographer of this image. Visible in the distance on the Newcastle shore is the land cleared for Clarence and Lena Hunt's farm, which is still in the Hunt family today. (Arthur Jones.)

Eldon Clark Hunt, son of Clarence and Lena Hunt, grew up on the farm in Newscastle overlooking the lake that had been in the family since 1890. In 1938, Eldon purchased land for his own farm from Edward Hall. The farm was located about a mile up from his parents on Bunker Hill Road. A year later, Eldon married Ethyl "Beryl" Hodgkins Hunt, and by 1957, they had five sons. They are shown above from left to right as follows: (first row) Norman, Raymond, Donny (his given name was Eldon, but everyone called him Donny), and Wilder; (second row) father Eldon and Forrest. Eldon was proudly self-employed as a farmer and lumberman and was active in the Masons, the Bunker Hill Grange, and Bunker Hill Baptist Church. Beryl wrote the "Bunker Hill Column" in the *Lincoln County News* for several decades. The photograph below from 1952 shows that Wilder (left) and Donny enjoyed leaning on the calves in front of the silo and barn, although neither became farmers. (Both, Wilder and Ellen Hunt.)

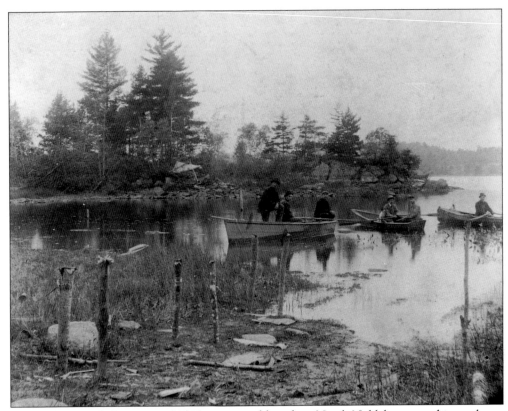

In this photograph from around 1900, a group of friends in North Nobleboro posed in rowboats along the eastern shore of the lake near Morang's Cove. A professional photographer probably took the picture. From left to right in the first boat are James Eugley (standing), William "Tom" Donnell, and Hudson "Hud" Nash. In the second boat are H. Watton with a dog and Net Cole. Almore Eugley is pictured alone in the third boat. (Thomas Moody.)

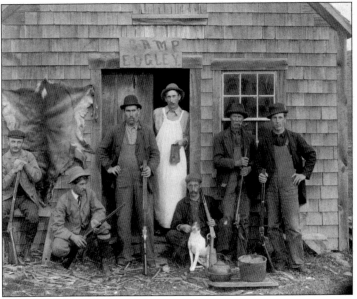

Around 1900, a series of photographs was taken in front of an outbuilding on James Eugley's farm near East Pond Road in Nobleboro. Pictured from left to right are Net Cole, H. Watton, Tom Donnell, Hud Nash, James Eugley, Almore J. Eugley, and Ernest A. "Pat" Dermuth. These friends probably posed for this photograph on the same day as the boat outing above. (Thomas Moody.)

Henderson W. Moody (1870–1952), son of William H. Moody, posed next to his father's house on East Pond Road in North Nobleboro around 1900. Henderson was a farmer, as that term was loosely used back then. Like other farmers, Moody did many kinds of work, including roadwork, lumbering, barrel making, cedar shingle cutting, beekeeping, and apple growing. (Thomas Moody.)

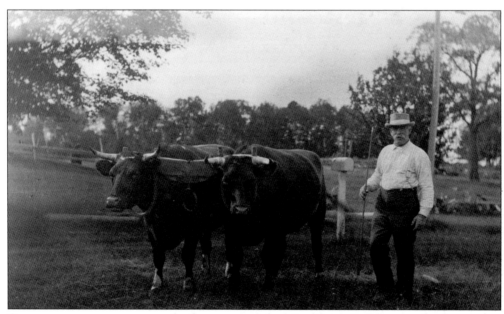

Oxen teams were common on the farms around the lake. Not only did oxcarts haul enormous trees out of the woods to the lake, but diaries also tell about oxen teams moving existing houses several miles to new sites, usually in winter over the frozen lake. Oxen competed in pulling contests at local fairs and still do. (Thomas Moody.)

Herbert Moody and sons Ainsley and Delbert built the Moody family cottage in 1921 on Morang's Cove near Asa Moody's home. It was a place for frequent family picnics and get-togethers. As seen in the next three pictures, the cottage was slowly updated over the decades as it was passed along to later generations of the Moody family. (Thomas Moody.)

Shown lounging in front of the Moody cottage porch in this photograph taken in 1950 are, from left to right, the following: Forest Kennedy, Thelma Donnell Moody, Edna Donnell Spear, young Bobby Spear, Herbert Spear (with gun), and Ruth Kennedy. Ruth Kennedy taught at the Tennyson School on Upper East Pond Road around 1940. The Spear family operated a dairy farm on Eugley Hill. (Thomas Moody.)

When Margaret Moody Wellman and Lester J. Wellman Jr. owned the cottage, part of the porch was removed, and the front porch was made into a three-season porch. In 1978, son Mitchell Wellman (right) relaxed on the rocks along the shore while his father watched from the front stairs. Now the cottage is in the Wildwood Shores development and has electricity, but it still lacks running water. (Margaret Wellman.)

The Moody-Wellman cottage was well known on Damariscotta Lake, as it was the only cottage that boasted a four-hole outhouse. In a four-holer, the seats (holes actually) were different sizes, so children did not have to worry about falling in and adults were comfortable. The outhouse is still in good shape and in use. (Margaret Wellman.)

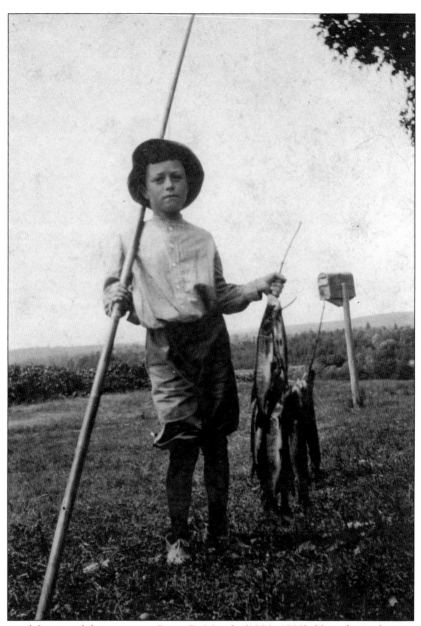

This successful young fisherman was Percy B. Moody (1900–1992). Here, he is shown standing on a hill in North Nobleboro with the lake in the background in about 1912. In 1930, Moody and his wife, Bertha, opened a food stand to serve the summer guests who stayed in the family's Waldoboro cabins near US Highway 1. The food stand grew rapidly to become the renowned Moody's Diner. By 1934, it expanded to its current location on the highway, where it is still a popular Maine destination. In addition to maintaining the diner, Moody operated a farm in Nobleboro with milk cows, pigs, chickens, and Christmas trees. In the 1950s, they started the Moody's Island Campground, which was open for several years. Percy learned about working with tourists from his parents, Asa and Emma Bickmore Moody, who ran Moody's Rest Cottage and rented rooms near their home on Morang's Cove on Damariscotta Pond in the early 1900s. (Thomas Moody.)

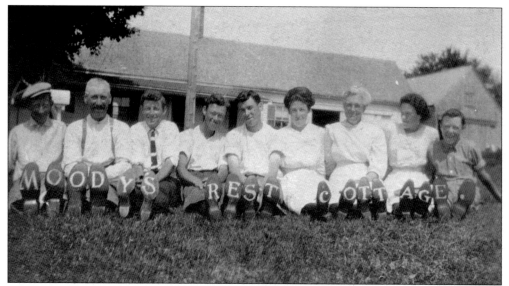

This promotional postcard for Moody's Rest Cottage from 1910 was taken in front of the ell of Asa and Emma Moody's house on the eastern shore of the lake in North Nobleboro. Shown from left to right are the following Moody family members: unidentified, Asa Moody, Louis Moody, Irving Moody, unidentified, Belle Moody Furbush, Emma Moody, Dot Moody Eaton, and a smiling, young Percy Moody. James Maxim built a lakeside home on this farm during the 1990s. (Thomas Moody.)

In about 1928, Walter Donnell's four children may have taken a drive in his big Moon automobile. Back then, children drove tractors and automobiles as soon as "they could reach the pedals." The driver was Chet Donnell, Lois Donnell Vannah leaned on the side, and Edna Donnell Spear looked out from the back seat with her sister Thelma Donnell Moody in the shadow. (Thomas Moody.)

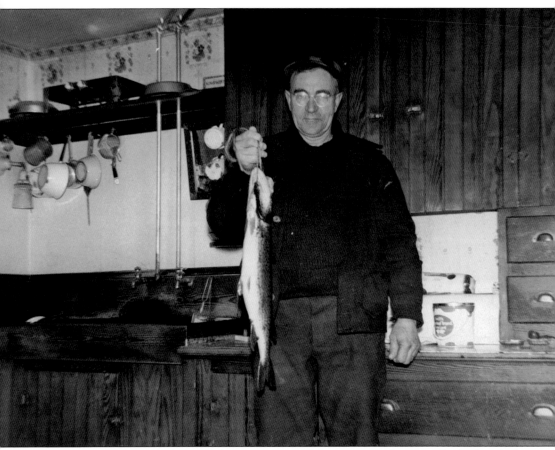

Walter Donnell, who had owned the Moon automobile 20 years earlier, proudly displayed a large pickerel caught in Damariscotta Lake in 1951. He was in the kitchen of the William Moody farmhouse, which was built about 1840. The kitchen's dark wood cabinets and a black iron sink are reminiscent of the early 1900s. Thomas Moody, who helped with this book, currently lives in the William Moody farmhouse. Donnell's family is a good example of the intertwining families that are common around Damariscotta Lake, as his mother, Emma Eugley Donnell, was of the fifth generation of German immigrants that came to Waldoboro in the mid-1700s and moved to Nobleboro. Her ancestry included the Eugley (Ukele), Benner, Waltz, Umberhind, and Vannah (Werner) families. (Thomas Moody.)

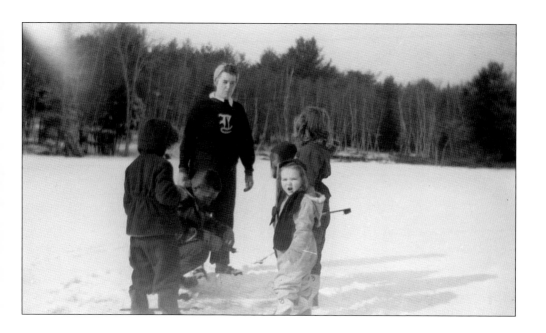

Shown in the above photograph from the 1940s, Helen Spear Donnell Pietila (standing in the middle) was ice fishing with her husband, Chester Donnell (second from left, squatting), and her four girls, from left to right, Patricia, Sandra, Pamela, and Jackie. The photograph below shows Helen, always one to do things right, checking to be sure the line was rigged correctly and waiting for a bite. Pickerel were the primary fish caught in the winter; trout, perch, and bass were more commonly caught in the summer. Before the 1940s, many women had smokehouses on their farms and sold the extra smoked fish. Helen has a reputation as one of the best cooks and the best cookie and pie baker in North Nobleboro. She still lives in the same home near Sulo's Road. (Both, Thomas Moody.)

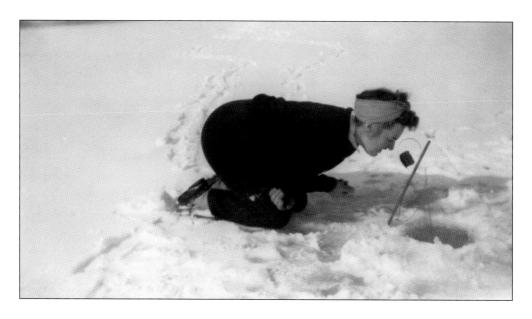

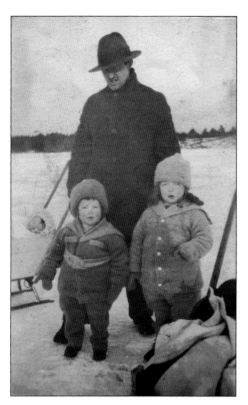

In the 1920s, there was much winter activity on the lake. Melrose Jones took his three bundled-up children, Arthur (left in carriage on sled), Ruth, and Mellicent, for a sled ride out onto the ice. Jones always loved the outdoors. In the winter, he would spend time with his children or go iceboating with friends. In the summer, he boated and spent time on North Star Island. (Joyce Ball Brown.)

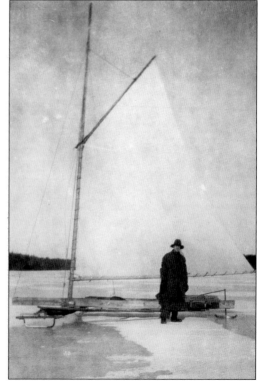

Since the lake is about 12 miles long, iceboating in the wide-open space was a fast and fun sport. Shown in 1921 with his iceboat, Melrose Jones skimmed up the South Arm from his home in Damariscotta Mills all the way to Jefferson; he was said to have reached a speed of 60 miles per hour. Son Arthur, Arthur's friend George Weston, and nephews Richard and Michael Ball all remember taking wild iceboat rides on windy winter days. (Arthur Jones.)

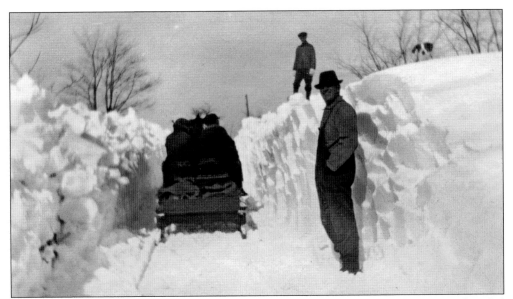

After a blizzard in the early 1920s, Henderson Moody is shown standing in the narrow, shoveled roadway. R. Ellis Moody, Henderson's son, was on the snowbank with his dog. Property owners were responsible for clearing the road in front of their properties, whether by shoveling, using a horse-drawn plow, or using a horse-drawn heavy drag, which packed the snow down so traffic could continue on top. (Thomas Moody.)

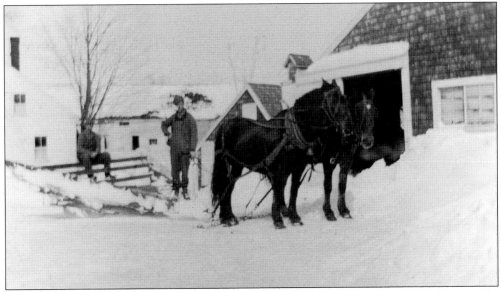

This horse-drawn snowplow was nicknamed "the Heater." This photograph from February 1934 shows Henderson Moody sitting on the plow and R. Ellis Moody standing next to the horses, Kit and Babe, who met an untimely demise. When logging, one started sinking in a bog and the other horse was dragged into the bog as well. Unfortunately, both had to be shot. The icehouse is the small dark building behind the plow. (Thomas Moody.)

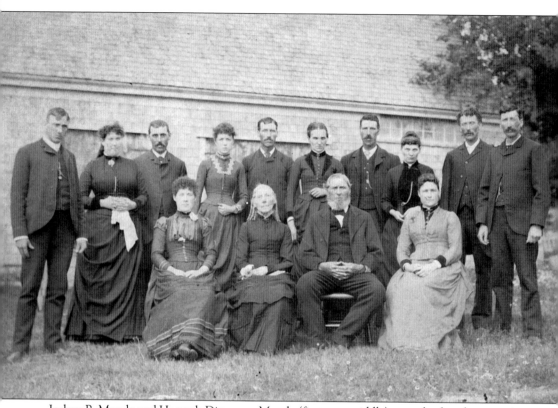

Joshua B. Moody and Hannah Dinsmore Moody (first row, middle) were the fourth generation to farm the same land along East Pond Road in North Nobleboro. Pictured here are their children and spouses in 1890. About 150 years earlier in 1762, John Moody settled his family at the head of Webber's Cove (now Morang's Cove) on the east side of the lake at the urging of James Noble, who recruited families to the Damariscotta Mills area and established the town of Nobleboro. Much of the farmland is still in the descendants' hands and has been worked as a farm for eight generations. Tom Moody (eighth generation) lives in the William Moody (fifth generation) farmhouse. The family has restored two English-style barns that were built sometime between 1790 and 1810. Tom's father, Harold Moody (seventh generation), and Tom's brother, Tim Moody, continue to harvest the hay crop on the farm. Harold's father, H. Ellis Moody (sixth generation), started a dairy farm in the 1930s, which they operated until the 1990s. Like other families on small farms, Harold remembered working other jobs like paving East Pond Road and installing telephone and power poles. (Thomas Moody.)

Lloyd Moody posed with the two-oxen team and sled in front of the Asa Moody home about 1910. Despite being a Victorian woman, Belle Moody Furbish (in dark dress) was a member of a Boston Women's Banjo Society. Eva Moody Flagg (in light dress) holds her daughter Thelma Flagg Kennedy. (Thomas Moody.)

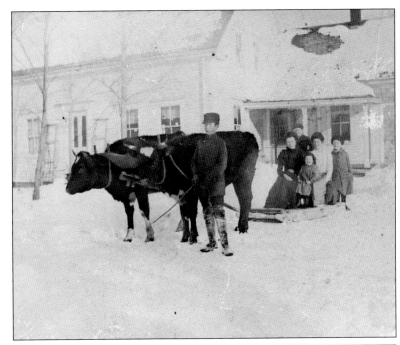

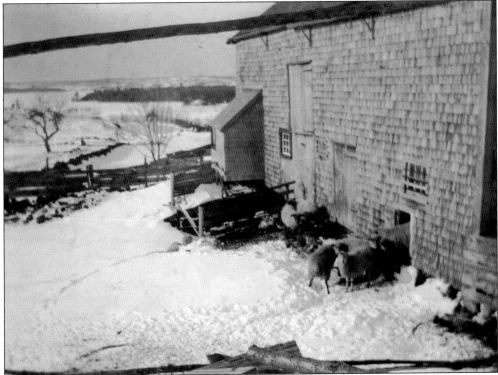

In 1890, the Moodys raised a small flock of sheep, as did many local farmers. The wool was used at home to provide warm blankets, gloves, socks, mittens, and more for the family. On most farms around the lake, sheep were taken to the lake; they were washed before they were shorn to get the wool clean for carding and spinning. The frozen lake is in the distance. (Thomas Moody.)

Since the trees had been stripped from the fields around the lake, the Asa Moody family planted evergreens as a commercial Christmas tree crop along the east shore of Damariscotta Lake. This photograph from 1890 shows the trees were cut and bundled to be shipped on the Knox & Lincoln Railroad and then stored in warehouses in Boston. The Moodys traveled to Boston to sell the trees in mid-December. (Thomas Moody.)

Percy Moody continued the family Christmas tree business into the early 1970s. Here, Chester Donnell transports trees from the Donnell homestead. Moody and his wife, Bertha, also enjoyed the Boston sales trip and were the longest-established tree retailers there. Bertha enjoyed the break from the hard work of running the kitchen and the family cabins at Moody's Diner and used her time in Boston for Christmas shopping. Some of her purchases included crates of citrus and grapes. (Thomas Moody.)

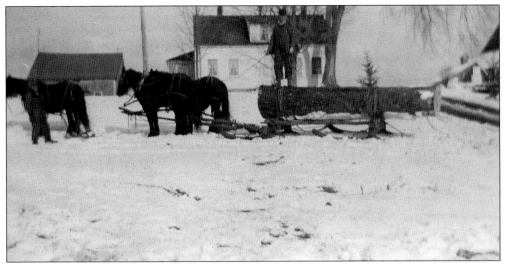

In 1915, some very large trees still stood in the woods around the lake. In the winter, the trees were cut, loaded onto horse carts, and hauled to the lakeshore; when the lake thawed in the spring, the logs would be floated to the sawmills. James Moody stood on one of these logs in front of the William Moody farmhouse. (Thomas Moody.)

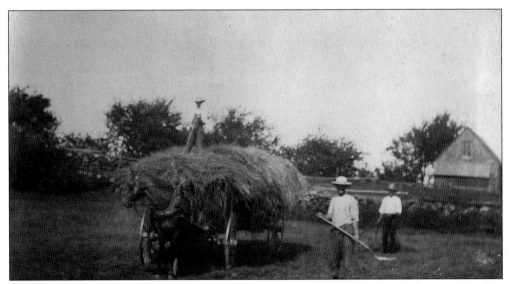

Photographed around 1908, this horse-drawn hay wagon worked the Moody farm. A Glendon Camp Meeting building can be seen in the background to the right. The building was moved there to store Henderson Moody's Model T automobile. Fruit from the extensive apple orchards (behind) was picked and stored in brick bins in farmhouse basements. In the winter when the family needed money, they took barrels of apples to the railroad station at Winslow's Mill, where commercial buyers would purchase whatever the farmers had for sale. (Thomas Moody.)

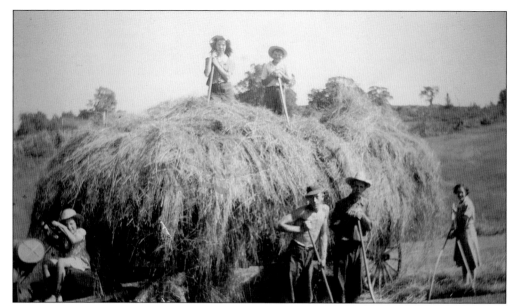

Work was done by the whole family; on this day, Marie Donnell Ashworth and Harold Moody were on top of the wagon while Maynard Howell and R. Ellis Moody worked with pitchforks and Thelma Donnell Moody used a loafer rake (note the wishbone-shaped handle) to gather the hay scatterings so that none was lost. The homemade tractor, driven by 11-year-old Norma Moody Dion, was constructed by converting an old truck and shortening the frame and drive shaft. (Thomas Moody.)

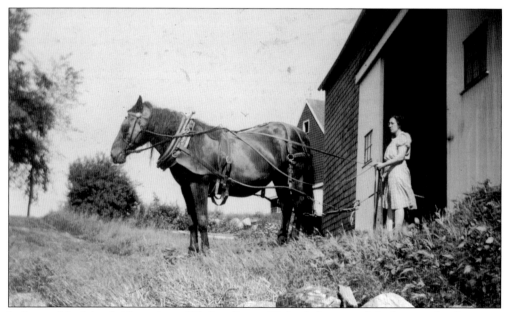

In front of the Moodys' lower barn, Thelma Donnell Moody harnessed the horse to hitch up to a field wagon or cart. Although there were tractors in 1945, they were difficult to get during World War II. At this time, much of the work in the fields was still done using horses, and horses and carts still traversed East Pond Road and the many other dirt roads in Nobleboro. (Thomas Moody.)

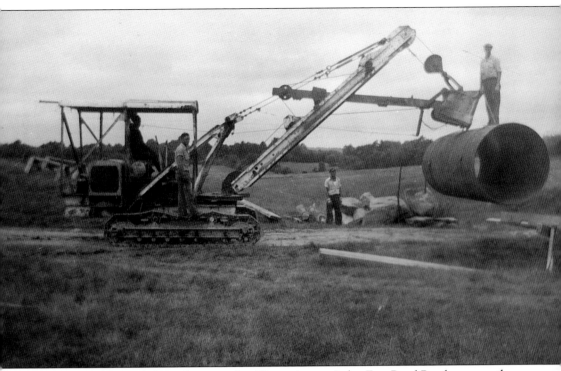

The major road located along the east side of Damariscotta Lake, East Pond Road, was mostly a narrow dirt road until the late 1940s and 1950s. This steam shovel from the 1940s was used to replace a stone culvert near Maynard Howell's home with a new metal one. The work crew was composed of local men. Sporadically, crews of local men—including farmer Hudson Vannah, who was Nobleboro's road commissioner for many years, and farmer Harold Moody—paved sections of East Pond Road with tar. The road was completed in the early 1960s. The hot liquid tar was spread on the dirt and gravel roadbed by the bucketful; a thick layer of sand was then hand-shoveled over the tar to be worked in over time by passing vehicles and enjoyed by mischievous kids. Howell built a dam on one of the streams flowing into the lake and operated Lakeside Lumber from 1946 to the mid-1950s. (Thomas Moody.)

The Damariscotta Lake Association was founded in 1966 as a grassroots group of lakefront property owners concerned about fluctuating lake levels. The founding president was George Birkett (right). By the mid-1970s, Damariscotta Lake Association board meetings featured much discussion about lake pollution, and by the end of the 1980s, the board came to believe that nonpoint source pollution was the most serious threat to lake water quality. With an expanded emphasis on the lake's watershed (the land over which water drains to the lake), the nonprofit expanded its name to Damariscotta Lake Watershed Association in 1990. Since its founding, the group has expanded its mission to include programs in education, nonpoint source pollution abatement, invasive plant early detection and prevention, youth recreation, water quality monitoring, and land conservation. The association has always been dependent on dedicated volunteers who are motivated to protect the lake they love. The nonprofit continues to pursue its mission of "enhancing the quality of life in and around Damariscotta Lake, [and] assuring enjoyment for all of its natural and human residents." (Newcastle Historical Society Dinsmore-Flye Collection.)

Three

GREAT BAY AND DAVIS STREAM

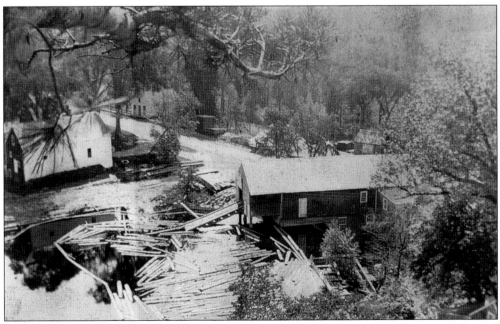

A dozen mills used the power of the streams running into Davis Stream in Jefferson to full wool, grind grains, and saw lumber, staves, and shingles. In 1827, brothers Joseph Weeks (1793–1870) and George Weeks (1805–1879) built this long sawmill on the West Branch. It provided lumber for the Waldoboro shipbuilders. Clifton Bond took this photograph in the 1940s when climbing a tall pine to cut off a problem branch. (Ralph Bond.)

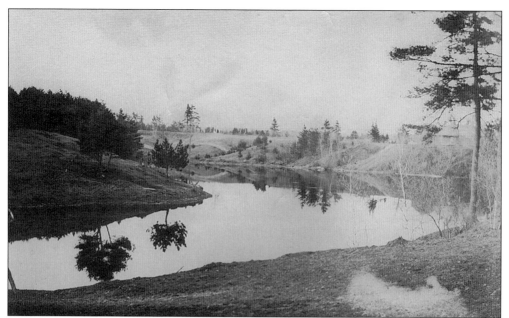

In 1827, the Weeks brothers built a wooden dam across the West Branch of Davis Stream, flooding about 10 acres to form the Mill Pond. The mill continued to use waterpower every spring until its conversion to diesel power in 1952; it operated until 1964. The Mill Pond was a favorite ice-skating place for locals. (Ralph Bond.)

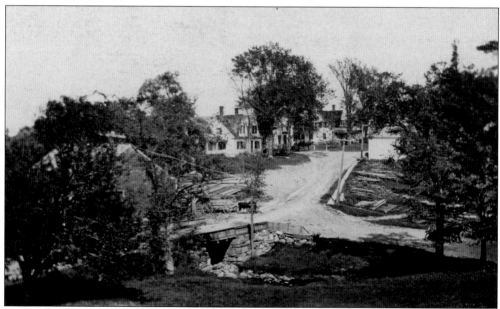

A community of homes and businesses developed near the mill in Jefferson. Homes and at least three stores stood on the same side as the mill. Wooden sidewalks helped citizens keep out of the mud. On the right side were two stores, a casket shop and undertaker, and homes. The other mills that operated on the West Branch made staves, headings, lumber, shingles, and lime casks. The mills were named for the families who operated them: Clifford, Newall, John Meserve, another Meserve, Henry K. Bond, and Joyce. (Ralph Bond.)

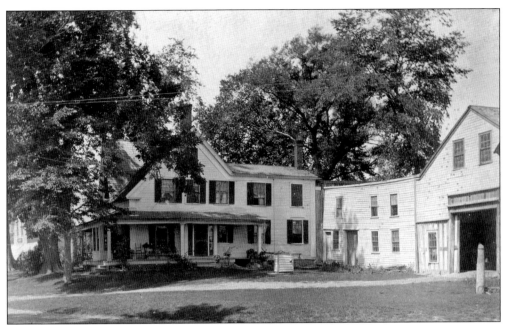

At the top of the hill and between two stores, Eva Weeks Bond operated a boarding home for travelers and businessmen (above). The store west of her boarding home was built by Samuel Bond and operated by him for many years. Later, it was known as the Richardson store. To the east of her house was Henry K. Bond's store. The photograph below shows the J. H. Ames store. It was located on the opposite side of the road, directly across from the intersection of today's Valley Road and Route 126. The general stores throughout the town provided needed items and served as gathering places to exchange news and tell stories. (Both, Ralph Bond.)

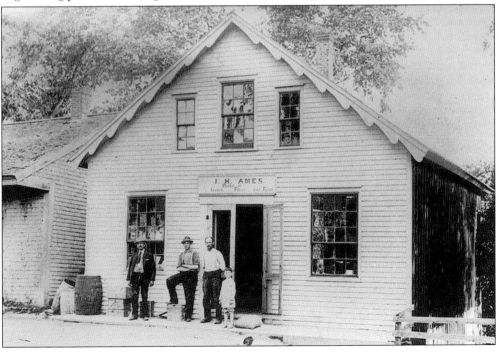

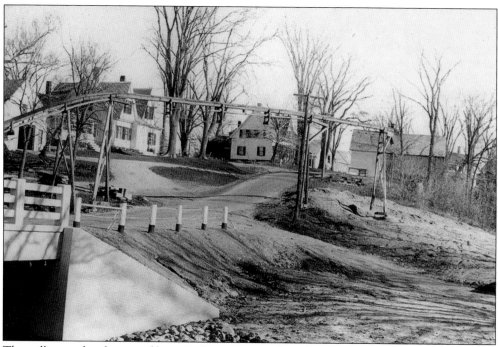

The mill, owned and operated by several generations of Weeks relatives, was the economic anchor for the community. Joseph's son-in-law Edward Y. Meserve (1833–1901) joined the business in 1868. Meserve's son Jim (1870–1958) began his 70-year career as a sawyer in 1888. Basil Achorn (1902–1976), another relative, later joined the business. The sawdust elevator, which Achorn designed and installed to move the sawdust from the mill across the street, is visible in the photograph above. Directly across the road from the Weeks-Meserve Mill was the essential blacksmith shop (below). Isaiah Johnson ran the shop first and was succeeded by Marden, his son. The shop shoed horses and oxen (who are less cooperative), performed carriage work, and created or repaired anything made of iron. (Both, Ralph Bond.)

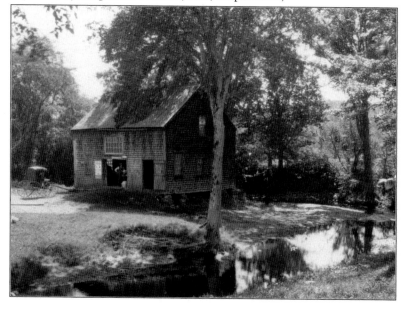

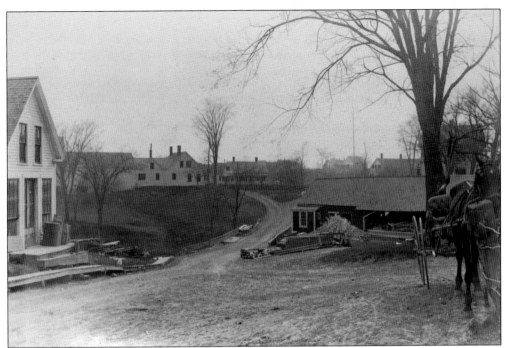

Sometime between 1909 and 1910, a bandstand was built in a small triangle of land at the intersection of Valley and Washington Roads in Jefferson. To the left was a small mill that made ax and tool handles. In the photograph above, the houses that look back towards the mill on the left are still standing. The Richardson home is to the left and the Marden Johnson home is in the center. An Austin Jones map from 1834 identified Chapman's brickyard in a low area bordering the river below the Richardson home. The photograph below follows the road past a neat picket fence on the right and beyond the mill. The house on the left, which also served as the post office and a dentist office, burned, but the original village school seen on the right still stands. (Both, Ralph Bond.)

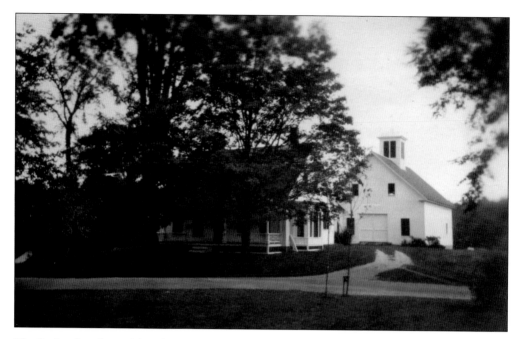

The Richardson home (above) was the home of Albert Richardson, a Jefferson native, store owner, and prominent lumberman in Old Town. He spent his later years there farming. Richardson saved a large collection of letters written to him between 1832 and 1881. Grandson Dr. Charles Richardson published many of these letters in a 1954 volume, *The Richardson Letters*. Local and national history came alive in the correspondence between these intelligent and thoughtful friends and relatives and provides readers with insight into their daily lives. Further up the road, wagons and patient horses waited for owners near the millinery shop. This prosperous, busy half mile of road was connected to the nearby bridge area by a row of houses and later the Grange hall, Masonic lodge, and canning factory. (Both, Ralph Bond.)

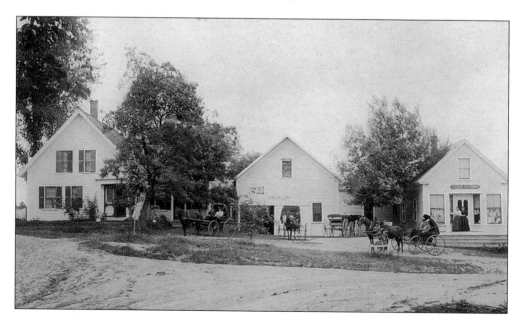

In 1951, Jim Meserve was still the main sawyer at the Meserve Mill. The original up-and-down saw had been replaced by a circular saw in 1886. Basil Achorn was an expert in setting up the machinery. Much of the production was used locally and included a great deal of custom lumber. The building burned in December 2002. (Newcastle Historical Society Dinsmore-Flye Collection.)

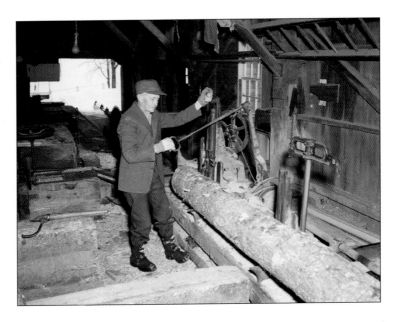

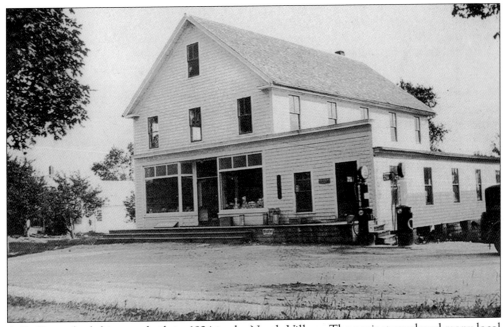

A.Q. Carter had this store built in 1924 in the North Village. The project employed many local men. George Hoffses was the last owner of the Bond-Richardson store. He and his son Harland, who was also the Jefferson postmaster, took over running the store. The building housed the store, post office, and gas pumps. Harland's son-in-law Marshall Holmes was the last to manage the store and served as postmaster until 1976. (Ralph Bond.)

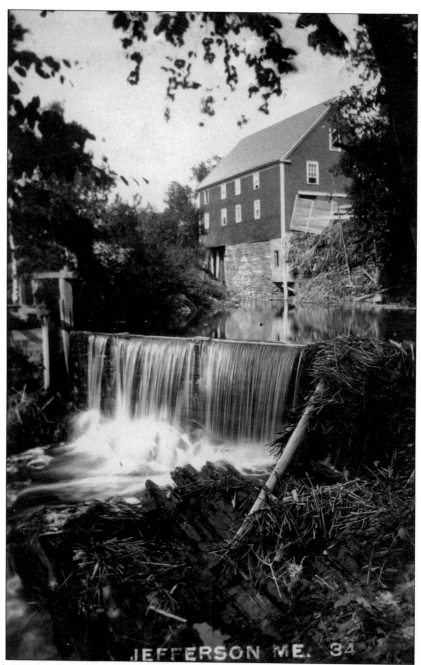

JEFFERSON ME. 34

Around 1780, brothers Samuel and Joseph Jackson rowed from Damariscotta Mills to establish a claim and construct a mill and dam just south of where Goose Hill Bridge now crosses the East Branch in Jefferson. This photograph of the later-built Davis Mill shows one set of three dams. After the Jacksons, Frank Davis ran a large mill operation, which contributed to Jackson Stream being renamed Davis Stream. Davis operated the mill for several years until it was destroyed by fire. Other mills on the East Branch were Charles Davis's mill, which thrashed grain and sawed lumber, and Albert Jackson and Joe Bond's gristmill, which also turned lathes. Nat Davis's mill ground flour using a millstone. (Ralph Bond.)

Haskell's Tavern and Hotel (above), owned by Capt. Elias Haskell, was an imposing early building. It was located just east of where the bridge stands today in Jefferson. It had an enviable location on navigable water near the mouth of the lake. In a letter dated August 1, 1832, Abiathar Richardson invited his 18-year-old cousin Albert Richardson along with his sisters "to meet George Weeks and himself at Captain Haskell's Hotel at nine in the morning to go on a sailing party." In the early 1870s, Calvin Haskell added a large addition (below) to his father's tavern. The Lake House had 40 guest rooms and a full livery stable. It was a local social center, a stopover on the stage route, and an early destination for travelers coming up the lake by steamboats. (Both, Ralph Bond.)

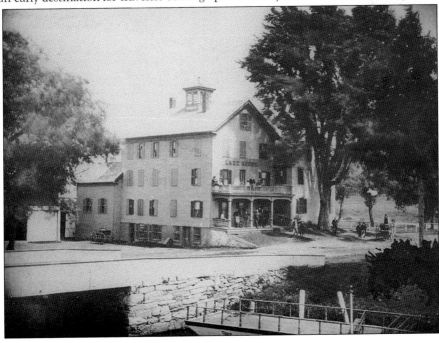

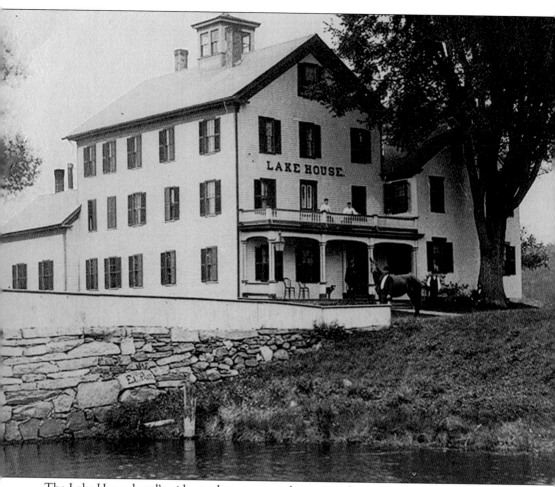

LAKE HOUSE.

The Lake House hotel's wide porches were popular sitting places. Early in the 1880s, B.P. Brown purchased the hotel, renovated the rooms, and advertised updated dining services. He owned impressive carriages and several matching pairs of horses. The jet-black horses were used to pull the town hearse. One long wagon was painted bright red with the words Jefferson Band written on both sides. An inferno destroyed the complex in 1899. Its location was slightly upriver of the wharf where steamboats and barges had docked to transport people, lumber, and freight since the early 1800s. One of the earliest steamboats was a side-wheeler named *Jefferson*; it was built by Haskell and Company, which operated on the lake in 1837. In 1874, local owners of the Damariscotta Steamboat Company used the *Queen of the Lake*. In 1882, Brown bought the six-ton *River Belle* in Bangor. He brought the boat up the Damariscotta River and then overland into the lake. It made regular trips transporting people and freight between the railroad stations in Nobleboro and Damariscotta Mills, the Methodist campground, and Jefferson. (Ralph Bond.)

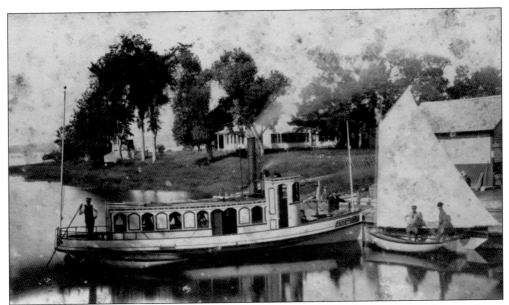

The crew of the *River Belle* included Brown's son Elmer, who was the captain, and an engineer. Cattail-reed-filled life preservers were imprinted *River Belle*. A controversy between Brown and the mill owners led to the passage of a law to prohibit the dumping of sawdust in the river and the dredging of the channel. Eventually, the boat was sold and worked at the coast. Boatbuilder, store owner, and prominent businessman Henry K. Bond built the sailboat named *Flirt*. (Ralph Bond.)

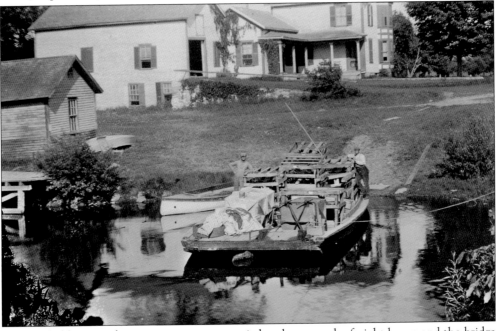

This loaded barge with its two-man crew was tied up between the freight house and the bridge sometime between 1904 and 1910. Store owner Leslie Sherwood Sylvester took the photograph, which is evidence that the lake was still used for transportation at this time. The goods on the barge may have been destined for the Sylvester Store. (Marilyn M. Speckmann.)

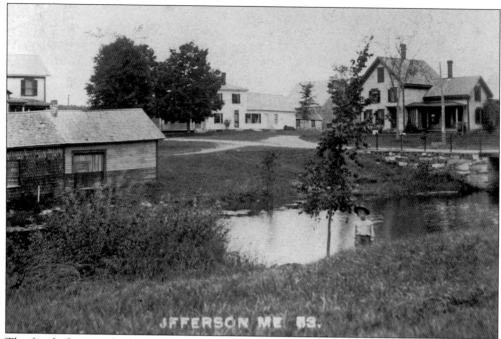

JEFFERSON ME 53.

The freight house, which is where the boats came to discharge people and freight, is shown at the left of this photograph from the early 1900s. The impressive house in the left center was built in 1814 and served as the first post office in Jefferson. In a 1934 interview, Bill Greenwood remarked, "Six pigeon holes took care of the mail." The original granite foundation is still part of the bridge. (Jefferson Historical Society.)

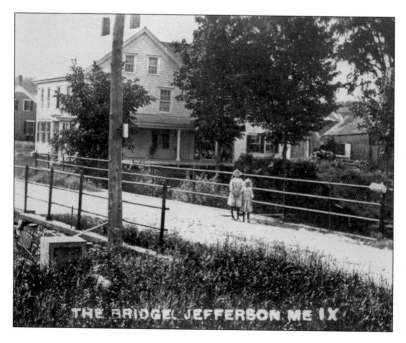

THE BRIDGE JEFFERSON ME IX

In 1908, sisters Dorothy (left) and Calista Sylvester stood on the bridge in Jefferson in front of the John Bond home (later the Meserve House) without its front porch. A mailbox to the right of the girls is proof that rural free delivery (RFD) had made it to this part of Jefferson. (Marilyn M. Speckmann.)

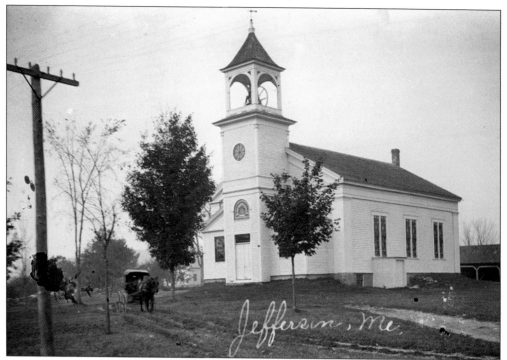

One of the first things Damariscotta Lake area residents did was to organize and build churches. In 1804, Jefferson's largest landowner and store owner, Nathaniel Bryant II, gave land and $732.63 for the building of the first meetinghouse. Dedicated in 1808, it became the First Baptist Church. This photograph from 1900 shows an electric pole and horse sheds behind the church. This structure was built in 1844 to replace the earlier meetinghouse; the vestibule and belfry were added in 1891. (Marilyn M. Speckmann.)

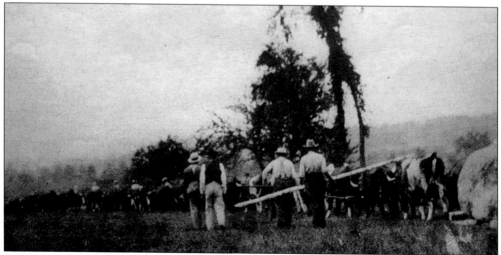

A main event of the 1907 Jefferson centennial celebration was the hauling of a 20-ton boulder from the lakeshore beyond Damariscotta Lake Farm to the lawn of the First Baptist Church. The task was accomplished using 22 yoke of oxen guided by 19 teamsters. On August 21, the boulder, adorned with an engraved plaque listing 12 of the earliest settlers, was unveiled in a well-attended ceremony. (Ralph Bond.)

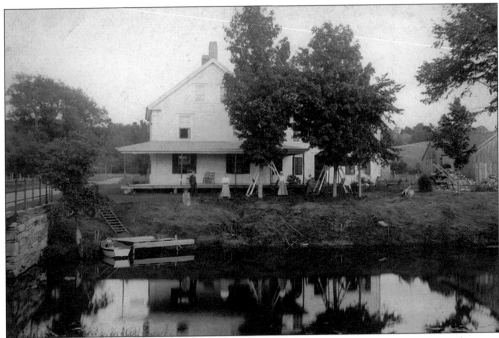

The Lake House eventually burned, making way for the Meserve House across the street to become a popular early boarding home for summer visitors. In 1918, Fred and Florence Meserve bought the John Bond house from William Vinal and his wife. They converted the Meeting Hall where the Good Templars Society had met into additional bedrooms, making 10 bedrooms available for summer boarders. The Meserve House had boats for the guests, and a front porch was later added to the structure. Fishermen and families came from near and remote cities. One guest was Thomas Watson, an associate of Alexander Graham Bell. Watson also later owned the successful Fore River Ship and Engine Building Company. (Both, Ralph Bond.)

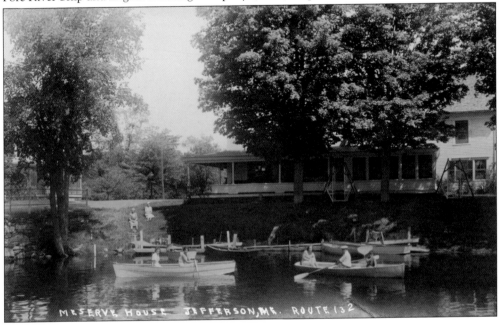

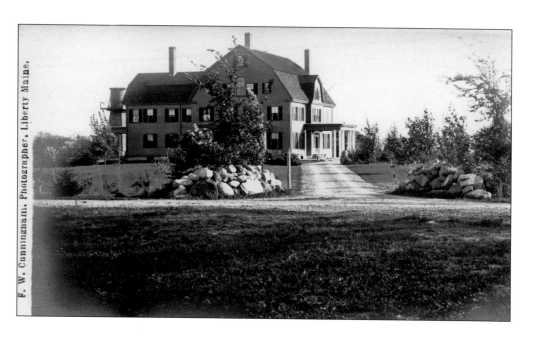

F. W. Cunningham, Photographer, Liberty Maine,

The largest private home in the bridge area was built in 1905 for physician Frederick W. Jackson. Jackson returned to Jefferson after practicing medicine in Providence. The home was situated on a 1,000-acre lot overlooking the lake, and the *Lewiston Journal* reported, "The land is being laid out in walks, groves, and gardens." A ballroom took up much of the third floor. In 1970, the Jackson family sold the home to Don and Theresa Rodrigue, who continue to maintain it as a beautiful family home. A large barn built for Jackson and a farm manager's home were located across the road. The farm had sheep, horses, and cattle. Bond Brothers Hardware and Lumber now operates its business there. (Both, Ralph Bond.)

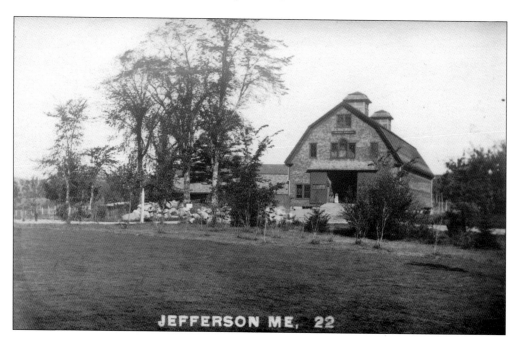

JEFFERSON ME, 22

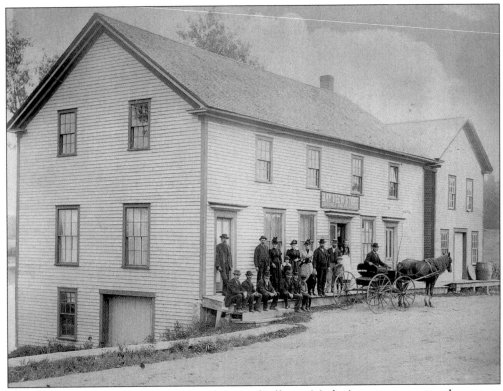

Briggs Farnum's Bay View Store (today, the site of Jefferson Market) was an imposing three-story building containing a grocery, general store, and post office. The second floor was used as a meeting hall and dance area. Adjoining it was a photographer's shop. The next owner was E.K. "King" Clark. The large building burned in 1893. Clark rebuilt a much smaller store and sold it to Leslie Sherwood Sylvester in 1903. (Ralph Bond.)

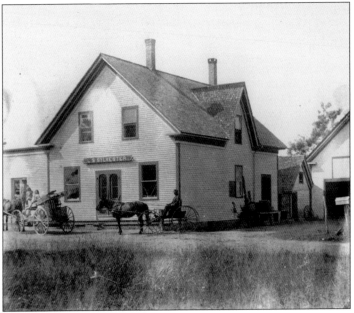

Les Sylvester added a grain room to the west side of the original store and later sold gasoline that he stored in a barrel. He and his wife, Lucy (nicknamed "Lutie"), lived in an apartment above the store before building the family home next to the bridge. Sylvester owned and operated the business until ill health caused him to sell the store to Ernest and Willis Bond in 1920. (Marilyn M. Speckmann.)

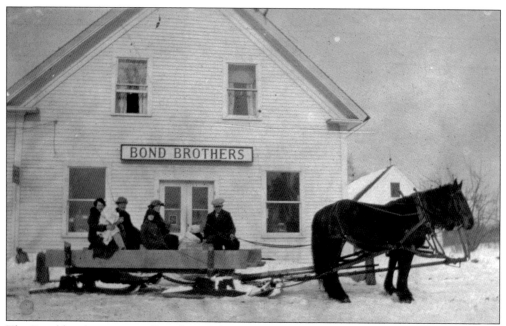

The Bond brothers eventually enlarged the store and built adjacent Dutch Colonial homes for their families. The photograph above was taken in front of Bond Brothers store during the winter of 1924–1925 by Willis Bond. Shown from left to right are his wife, Ruth Bond, holding her infant son Irvin; Catherina Bond, daughter of Nanci and Ernest Bond; Willis and Ernest's mother, Emma Bond; Avery Bond, son of Nanci and Ernest; Nanci Bond; Ernest Bond; and daughter Elsie. These entrepreneurial brothers expanded the business to include a sawmill and timberland, a gas station with an automobile repair bay, a box factory, an ice harvesting operation, and a storage building that stored and sold ice into the 1950s. The Bonds also built some of the first rental cottages on the lake. The store and gas station are shown in the photograph below, taken during the 1950s. (Both, Martha Bond Tompkins.)

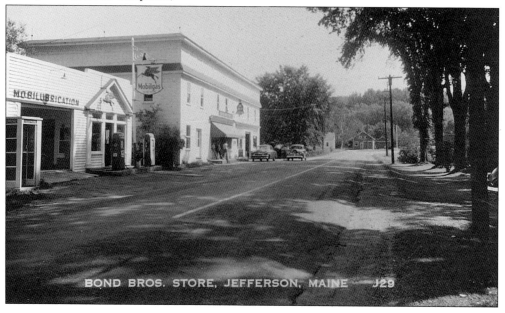

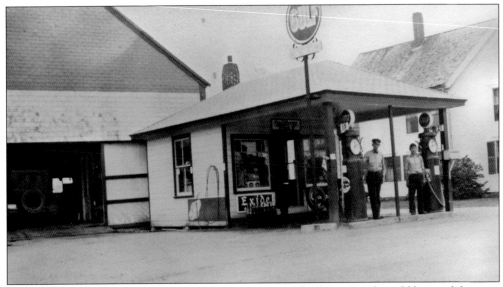

Fred Meserve opened his gas station in 1924 in a corner of his barn. He also sold bait to fishermen and other sundries. Later, a screened-in porch was added to provide a space for travelers to enjoy a Turner ice cream. Turner Centre Dairying Association was, at one time, Maine's largest creamery, and in 1917, the company offered the first commercial ice cream in New England. Meserve built this separate station in 1926. Later, the building was moved to the riverside where it was converted to a cottage. (Ralph Bond.)

Frederick "Rick" Jackson, son of Dr. Frederick W. Jackson, built his gas station on the other side of the bridge in 1946. He soon expanded it to accommodate school bus repairs. It still operates as a gas station and automotive repair business, formerly owned by Keith Jewett and now All Season's Automotive. (Ralph Bond.)

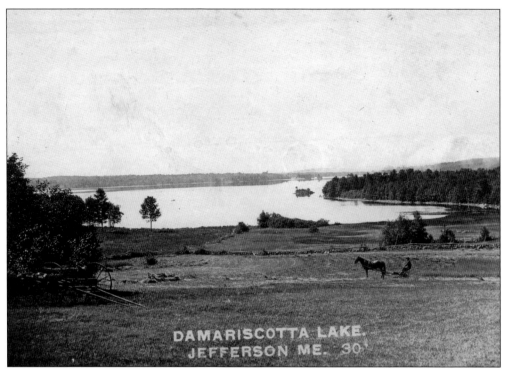

A solitary farmer hays a field off Bunker Hill Road between the Jackson farm and the lake in the early 1900s. Nearby stood the Town House, a store, a millinery shop, and a lawyer's office. Hides were tanned in three places along the nearby stream. No cottages were visible and much of the land was cleared for pastures and haying. (Ralph Bond.)

Around 1900, Avery Bond and son Harlan explored the east side of Great Bay in Bonds Cove in a homemade boat. Avery Bond, who was a farmer, wheelwright, and surveyor, was the father of Harlan, Ernest, and Willis Bond. Ernest and Willis developed local businesses under the Bond Brothers name. Harlan became a chemical engineer with DuPont. (Martha Bond Tompkins.)

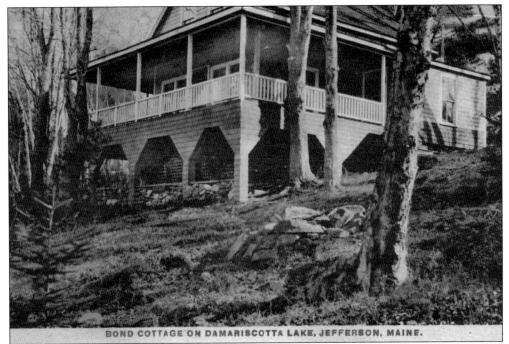

BOND COTTAGE ON DAMARISCOTTA LAKE, JEFFERSON, MAINE.

In 1912, Eva Bond had a cottage built on the east shore of Great Bay near Crescent Beach in Jefferson. As farms were abandoned and mills were closed, this first cottage was the harbinger of a sorely needed new industry that catered to tourists. The cottages to follow housed summer residents and visitors, including some famous guests such as Arthur Godfrey, who stayed at the large Louis Pieri cottage. (Ralph Bond.)

With transportation no longer the primary use of the lake, the recreational value of lakefront property gained a new significance. These well-dressed people in front of Eva Bond's cottage explored a partially sunken barge, which had found a new life as a dock to tie-off boats. The popularity of the newly built cottages for enjoying family time, boating, and fishing quickly grew. (Ralph Bond.)

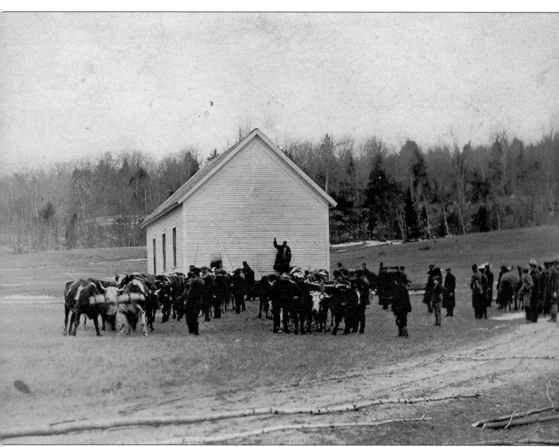

Although the lake's importance in business transportation lessened, winter was still an ideal time to move buildings. Oxen continued to do the heavy work. The Corner Schoolhouse (above), formerly located near the intersection of Linscott and Hodgkins Hill Roads, was headed for a new life down the road and across the lake in the 1920s. It became the dining room and kitchen for Del Andrews's newly opened Wawanock Camp for Girls at Wavus Point. In 1932, Henry Cunningham's oxen and other teamsters moved Roxie Benner's home from the village area, where it had been a millinery shop, to its new location near Fairview Cemetery. Despite breaking a skid, the move was completed in two days. The house had to be pulled across the Mill Pond to avoid the sawdust pipe over Route 126. Oxen teams moved many sheds, houses, and cottages to new locations in this traditional manner. (Ralph Bond.)

The longest stretch of sandy shore on the lake, Crescent Beach in Jefferson, has been a public beach for many years. In the late 1800s and early 1900s, the owner was George Kennedy. The well-dressed crowd (above) enjoyed the shade of a huge tree with its surrounding hammocks. Shown from left to right are Marden Johnson (village blacksmith), Eva Bond, Clara Jackson, Herbert Bond, Emilie Richardson, Jennie Johnson, Ralph Jackson, Foster Jackson, Frank E. Richardson, Prescott Bond, Forrest Bond, Amanda Bond, Samuel J. Jackson, Emmy Sidelinger, Ina Avery, and Samuel Bond. The beachgoers (below) in the 1920s looked as if they might even get into the water. Vincent Campbell owned the beach during the early 1960s and eventually sold it to James and Ellie Burns. (Both, Ralph Bond.)

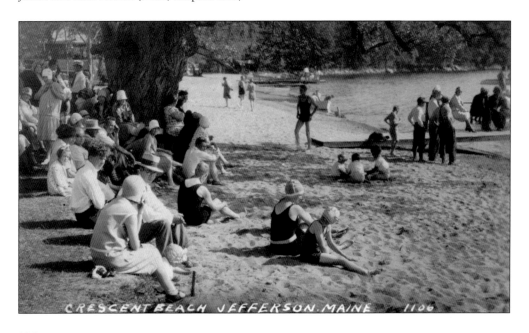

In August 1907, the community beach association (now the Jefferson Beach Association) voted to build the Centennial Bath House on its section of the beach. Around 1909, four friends climbed onto the roof of the old bathhouse. Eurva Carmen Marden (she later married Ralph Libby) stood at the door while another friend peeked out. Ralph Libby sat at the top right on the roof. (Libby family.)

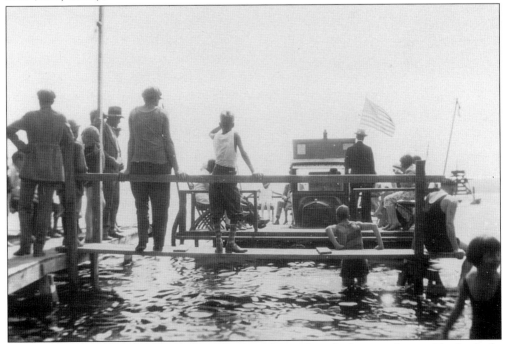

In the 1930s, prospective customers lined up for either a closer look or a ticket to ride the fresh-air taxi at Crescent Beach. The taxi had an automobile engine powering it and folding chairs for passengers to sit in. An American flag flew proudly at the stern. (Libby family.)

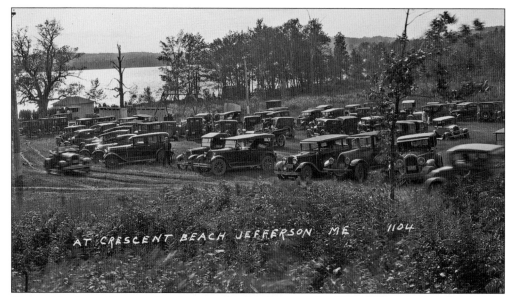

The parking lot at Crescent Beach was packed with cars in the 1930s. The crowd may have come to watch a special airplane event or maybe just to enjoy a nice summer day at the beach. The popular public beach had changing booths and offered refreshments. Nellie Ames ran a snack stand there for several years. (Ralph Bond.)

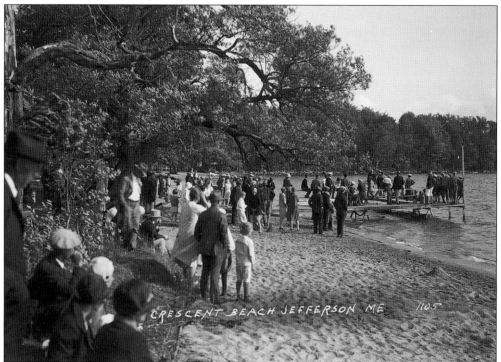

In 1935, excited onlookers watched from Crescent Beach. They could be waiting for a seaplane ride or for the fresh-air taxi to return. The large queue of people showed that there were many customers for the rides, which carried an admission price. None looked as if they came to swim. (Ralph Bond.)

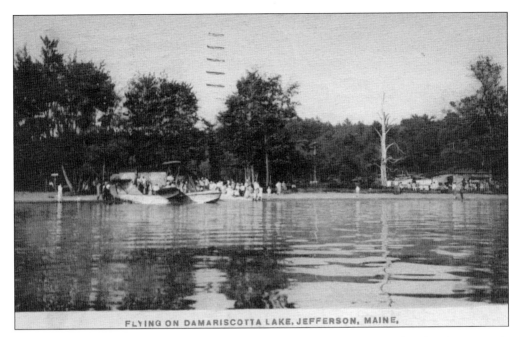

FLYING ON DAMARISCOTTA LAKE, JEFFERSON, MAINE,

The seaplane offered occasional rides for several years. It was a major event that drew large crowds of curious and courageous visitors who wanted to watch or ride on the plane as it lumbered out beyond the floats and diving board. Families often went to the beach after work to socialize with neighbors or enjoy a swim. In the winter, many ice-skaters gathered at the Mill Pond or off the beach to skate. Some skated down the lake to Muscongus Bay or Damariscotta Mills. Others drove their cars over the ice to visit friends, often entering from the beach. Locals recount stories of early cars that broke through the ice and may still be entombed. Lumber continued to be hauled down the lake by barge, and sawdust from the many mills rimmed the water's edge. (Both, Ralph Bond.)

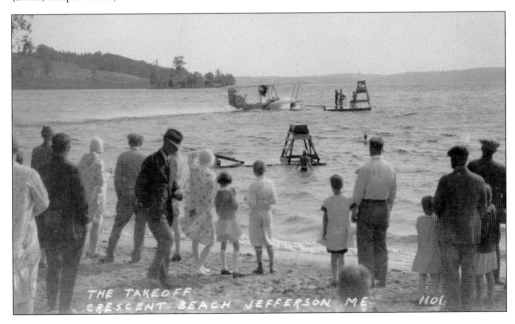

THE TAKEOFF
CRESCENT BEACH JEFFERSON ME. 1101.

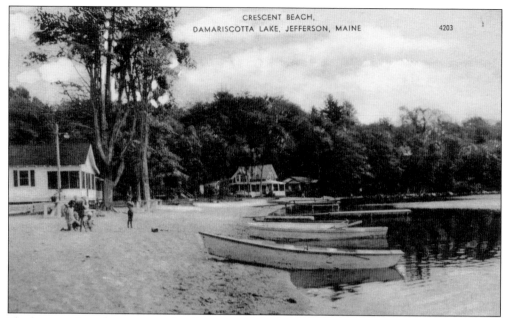

Flat-bottomed rowboats were a familiar part of the beach scene from the 1920s onwards. The American Red Cross held annual swimming classes on the beach for many years, working with beginner swimmers to advanced lifesavers. The beach was a popular place for locals and summer visitors. It is now part of Damariscotta Lake State Park with a section for the private Jefferson Beach Association. (Ralph Bond.)

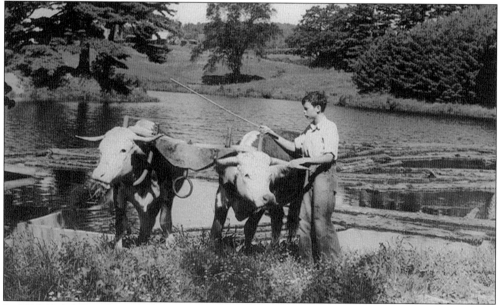

In 1938, Ralph Bond trained his team of young steers beside the log-filled Mill Pond. At the age of eight or nine, Bond walked a mile to Roy Cunningham's farm, purchased his first pair of oxen for $35, and walked them back home. Oxen were indispensable in clearing the land and doing heavy work. Jefferson teams still participate in Maine fairs. Today, Ralph and son David craft beautiful ox yokes that are sold throughout the country. (Ralph Bond.)

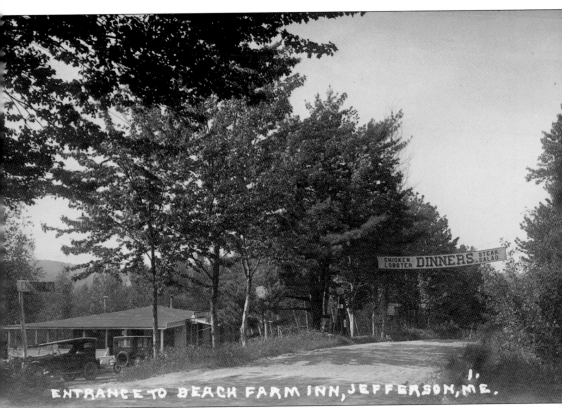

ENTRANCE TO BEACH FARM INN, JEFFERSON, ME.

The Beach Farm Inn was the project of Crescent Beach owner George Kennedy's wife. The establishment located up the hill from the beach provided an attractive luncheon room with a large porch facing Damariscotta Lake. Visitors entered from current Route 32. Summer guests from many states and from surrounding towns signed its 1929 guestbook. It closed around 1935. (Jefferson Historical Society.)

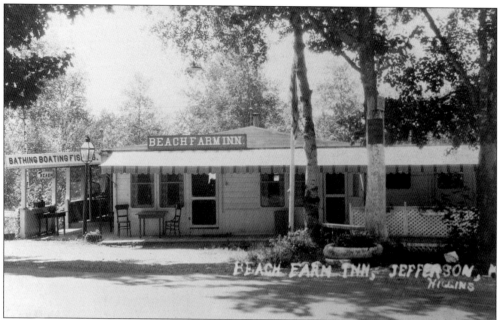

In a 1928 menu, a shore dinner (lobster stew, pickles, steamed clams, fried clams, half broiled lobster or lobster salad, potato chips, ice cream, cake, and tea, coffee, or milk) was listed for $1.50. Chicken dinners (soup, olives, pickles, roast chicken, peas, mashed potato, salad, dessert, and tea, coffee, or milk) cost $1. Sandwiches ranged in price from 10¢ to 35¢. Pies were 10¢–15¢. The brochure exhorted, "At the Beach Farm Inn this selection and combining of food for health as well as enjoyment is an art. Go the healthy way: It is irresistible. Do not oppose it. Go along with it." The back porch was a popular gathering place for locals as well as a place to hold meetings and enjoy the beauty of the lake. Mary Richardson (foreground) talks with Florence Kennedy, the owners' daughter (far right). (Both, Ralph Bond.)

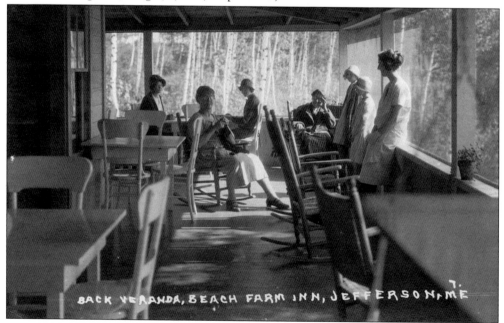

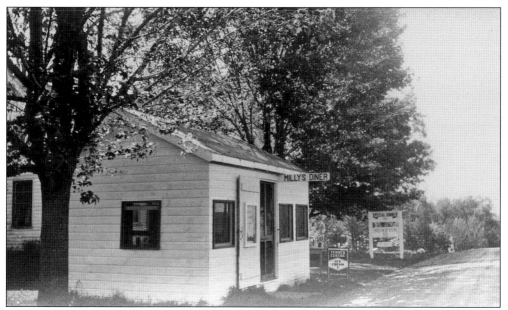

Millie's Diner, later a restaurant, was located just up the road from the beach near the intersection of East Pond Road and Route 32. Owned by Millie and Harold Pitcher, the diner served meals, snacks, and homemade pies. It was a favorite stopping place for locals, beachgoers, and travelers in the 1940s and 1950s. The smaller sign promotes Turner ice cream, and the larger sign advertises a chicken or steak dinner for 50¢. (Libby family.)

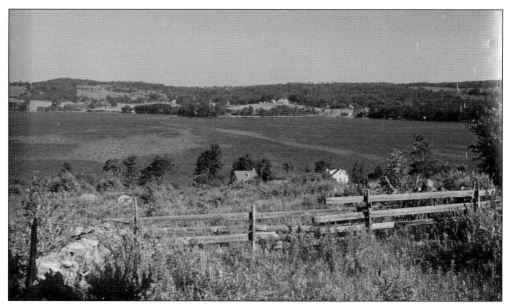

Olsen's field was located off East Pond Road. In this photograph from 1947, the view looks northwest over two early cottages on the shore, toward the First Baptist Church and Dr. Frederick W. Jackson's home. The farm had previously been owned by Lervey Castle. (Gary Olsen.)

On May 31, 1930, a very serious and proud young fisherman, Maurice E. Libby Sr., showed off the three-pound, three-ounce salmon he caught in the lake. His father, Ralph Rexford Libby, listed the fish he had caught in his journal from 1910; they included pickerel, trout, bass, perch, hornpout, and eel—not all were caught in the lake. According to Ralph's journal, he and other young men, including Chan Stetson, portaged canoes from the lake for miles looking for trout ponds. When Maurice turned 18 in 1936, he joined the Civilian Conservation Corps (CCC) at Southwest Harbor. The Maine Inland Fisheries and Wildlife Department currently has a stocking program to release brook trout, brown trout, landlocked salmon, and togue (lake trout) in the lake. The lake trout were first stocked in 1972. Largemouth bass became established in the early 1980s due to an unauthorized introduction. (Libby family.)

Harland Hoffses (left) and friend Prescott Bond caught this nice string of fish around 1912. Son of store owner George Hoffses, Harland was Jefferson's postmaster from the 1920s until he retired in 1957. Prescott Bond, the son of Henry K. and Eva Bond, served 36 years as the Jefferson rural free delivery (RFD) driver, beginning in 1923. He purchased a ski-equipped postal delivery van from Dr. Parsons in Damariscotta, but the vehicle made ruts in the snow-packed road, and Bond did not use it long. (Ralph Bond.)

In 1938, teenager Ralph Bond instructed brother Clifton's dog, Trixi, on the fine art of baiting a fishing hook. Trixi was considered to be the smartest and best dog around. Ralph later enlisted in the Air Force, serving as a B-24 bomber copilot in World War II. He retired after serving as Jefferson's RFD mailman for 28 years. (Ralph Bond.)

Chan Stetson from Sunset Lodge hooked a nice fish. The rower in the photograph was probably one of several local guides, such as Jake Day, Ralph Libby, or Perry Green, who were hired to ensure success for the guest fishermen each season. The lake had a population of native landlocked salmon in its deeper holes and small-mouthed bass, pickerel, and white perch throughout. (Ralph Bond.)

Ernest Merchant proved that even a broken ankle could not stop him from catching an impressive string of fish from the lake in 1946. Not much would keep this fisherman from his favorite pastime when he and his family spent summers at the home of his mother-in-law, Lucy Sylvester. Merchant found his special fishing places by lining up his boat with trees, flagpoles, barn peaks, rocks, and other landmarks on shore. (Marilyn M. Speckmann.)

In the 1940s and early 1950s, the highlight of the year for these girls was the annual overnight camping trip to the First Island in Great Bay. Supplies, gear, food, and campers filled a rowboat towed by a small outboard motorboat driven by chief cook and father of two of the girls, Ernest Merchant. From left to right are Anne Merchant, Emily Bond, Marilyn Merchant, and Beverly Bond. (Marilyn M. Speckmann.)

Teenage friends Anne Merchant (left) and Emily Bond had Davis Stream to themselves when adventuring on a raft. The two spent the summer of 1949 paddling and swimming from the raft they found, always accompanied by Emily's trusty dog, Twigs. Not all was play, as they also had a bait business selling night crawlers and frogs with their younger sisters. (Marilyn M. Speckmann.)

Ernest Merchant took his daughters Anne (left) and Marilyn for a paddle near the bridge in Jefferson in 1947. His wife, Calista, purchased the 18-foot Old Town canoe in 1929 as a college graduation gift to herself. The canoe had a passenger backrest, an optional rudder for sailing, and paddles with red trim to match the red-painted canvas. (Marilyn M. Speckmann.)

H. Raymond Bond, eldest son of Prescott and Marie Bond, built a beautiful boat in the Bond Boat Shop, now the site of the Jefferson Scoop. He carried on the local tradition of boat building. Boats of all sizes were built in garages, barns, and on the lakeshore through the years. (Ralph Bond.)

In the 1950s, a small armada of boats filled with teenagers could be seen on the north side of the bridge over Davis Stream in Jefferson. Non-powered boats were still the most common in those times, although five-horsepower engines were used on some boats. A few people had faster boats powered by very large and often cantankerous motors. The few classic inboard boats were admired. (Ralph Bond.)

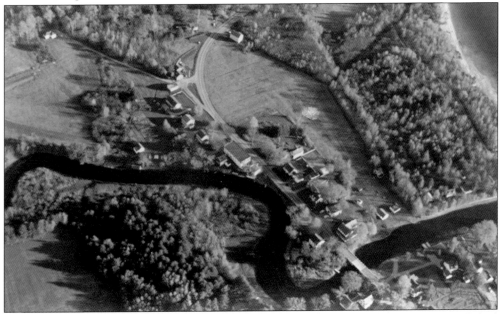

This aerial view of the bridge area and Davis Stream from 1961 showed that not much had changed in a number of years. The Meserve and Sylvester houses faced each other. Appearing on the left are Bond's Store, the residences of three Bond families, the old firehouse, a former Maine Forest Service building, and a glimpse of the Parlin home and barbershop. Across the street are Bond's Boat Shop and the family residences of the Orffs, the Vinals, and the Pierces. (Marilyn M. Speckmann.)

119

Sunset Lodge was a well-known traditional fishing lodge owned and operated by Chandler and Helen Stetson on the east side of Great Bay in Jefferson. In 1928, the Stetsons bought the lodge and six cottages from J. Edwin Morrissette and gradually enlarged the lodge and cottage complex to include 24 rustic camps. The main lodge, the office, and the dining hall all faced the lake. Guests could enjoy the sunsets across the lake from a circle of Adirondack chairs placed near the shore. (Ralph Bond.)

The Stetsons employed many local people as cooks, guides, waitresses, helpers, and cabin personnel. This early photograph showed employees Sadie (left) and Annie Pitcher taking a minute's break on the porch of one of the cabins. The cabin exteriors were boarded with hemlock slabs. (Libby family.)

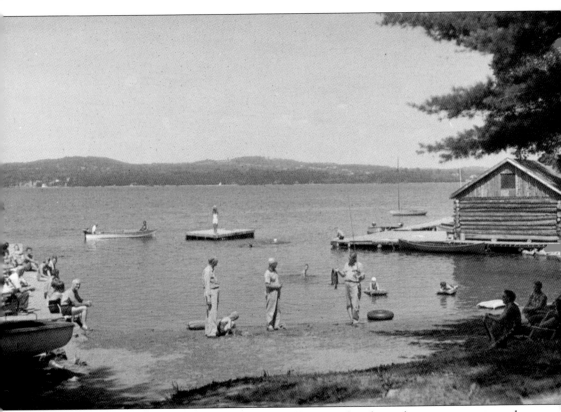

Sunset Lodge's busy waterfront showed the canoes, sailboats, and traditional green canvas-covered fishing boats available to guests. Annually, Chan Stetson took a miniature diorama he had made of the cabins and resort layout to the Boston and New York Sportsman's Show to promote the business. Helen redecorated several cabins each year, making new bedspreads and curtains during the winter. Families returned year after year to enjoy their vacations. Guests looked forward to the weekly special meals organized by Chan—one a full lobster bake with all the fixings and the other a steak cookout. Family-style meals were cooked by various talented local cooks and served inside the dining lodge. Telling 'yarns' in front of the roaring fireplace, sing-a-longs, and home movies were frequent events in the evening. Friendships were strong and lasting. Upon Chan's death in 1961, the business continued under the direction of his son and daughter-in-law, Bob and Aileen, until Bob's death in 1974. Sunset Lodge was sold and eventually, in 1987, became the property of the present owner, Aloisia Pollock, who rents out Sunset Cabins in the summer. (Jefferson Historical Society.)

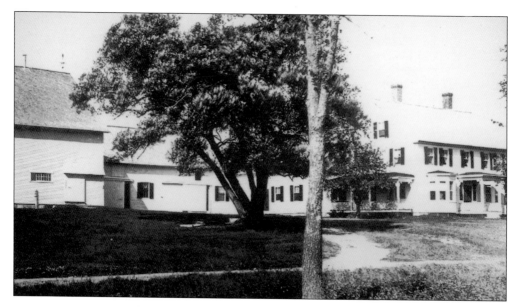

Damariscotta Lake Farm was another well-known fishing and hunting colony in Jefferson. It began with the main farmhouse, which was originally the home and tavern of James S. Waters and later the home of George and Mary Weeks. A plot map from 1840 showed plans for shops and businesses across the road, testifying to the importance of having this water-linked access to the railroad stations down the lake. George and Frances "Babe" Cleaves bought the property in 1949. They started with five prefab buildings made into cottages on the west side and were up to 20 when they sold the business in 1970. Many local people worked at the business. Hearty, farm-grown meals were served at the main house. Families returned year after year. Boats and motors were available to rent, and by 1955, a busy marina offered gasoline, food, and a boat launch. (Both, Ralph Bond.)

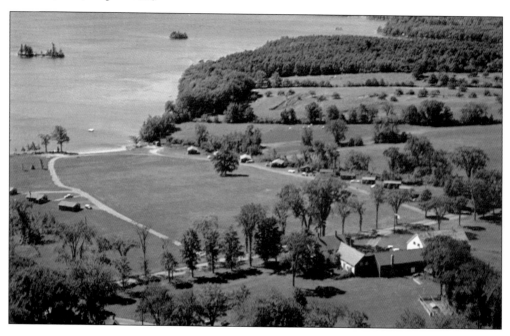

Owner Lloyd Hodgkins (left) and Paul Bond were ready to take a wild ride down Great Bay in the 1960s. Made of solid oak, *Windward* had machined steel runners and two canvas sails. Formerly owned by George Murphy, it took three hours to reassemble the frame and add the sails each season, but roaring along the icy surface at near 100 miles per hour was a deafening thrill. (Marilyn M. Speckmann.)

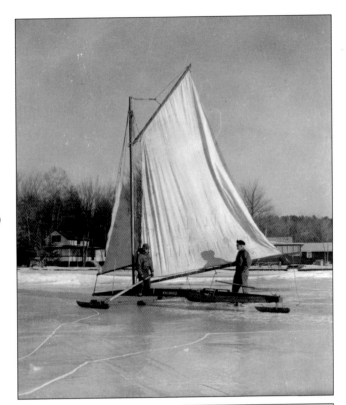

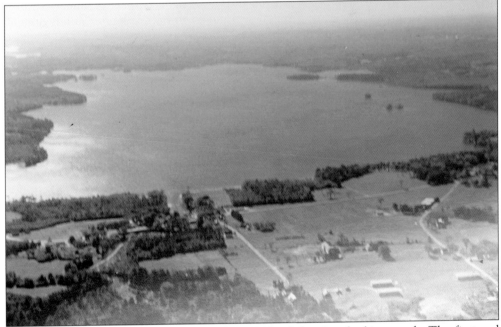

This aerial view from the 1960s shows the mouth of the river looking south. The first and second islands and Wavus Point are visible. Near the bottom of the photograph is Washington Road with Malcolm Tilton's two large henhouses; the Jefferson Village School is at the center. (Marilyn M. Speckmann.)

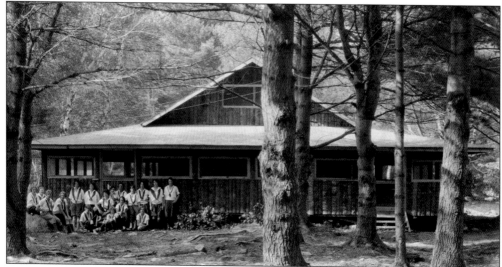

In 1922, Jefferson native Delbert Andrews and his wife, Emma, established Wawanock Camp for Girls on Wavus Point, also known as Huckleberry Point. The next year, 10 boys arrived for the boys' session of Camp Damariscotta. The two camps were known together as Wavus Camp. Here, Wawanock girls gather around their lodge. Wavus Camp has reestablished itself in a joint effort with Camp Kieve. (Kieve-Wavus Education, Inc.)

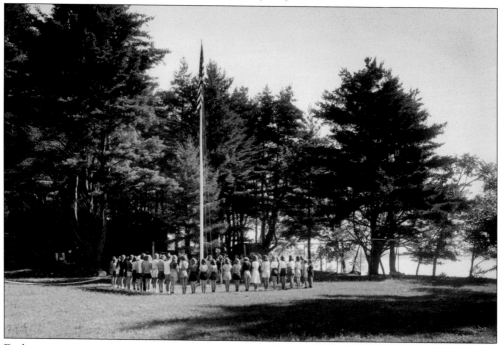

Each summer, campers would come to camp for six weeks at a time. While there, they participated in numerous activities, including water sports, canoe excursions, horseback riding, sailing, crafts, fencing, music, Native American lore, wilderness trips, chapel, camp songs, and character-building activities. Parents were able to make brief stays on Parents' Point. A number of former campers later bought year-round or summer homes on the lake. Here, the girls were participating in morning flag raising ceremonies. (Kieve-Wavus Education, Inc.)

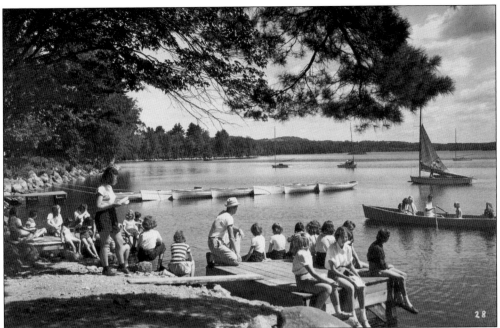

Proficiency in swimming and boating was stressed. Wavus sailing boats competed on their course near the camp. H. Raymond Bond built the catboats and comets. Lifelong friendships were made and a love for Damariscotta Lake was fostered. In the photograph above, campers enjoyed the waterfront. In the photograph below, the boys were lined up at the girls' swimming dock off the bridge between the mainland and Parents' Point. Two other summer camps operated in the Narrows area. Former Wavus camp counselor Larry Gates ran Camp Loon Echo for about six years during the 1940s, and William Prizer operated Chimney Point Camp during the 1950s. (Both, Kieve-Wavus Education, Inc.)

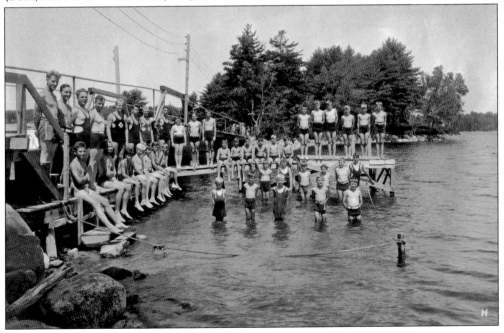

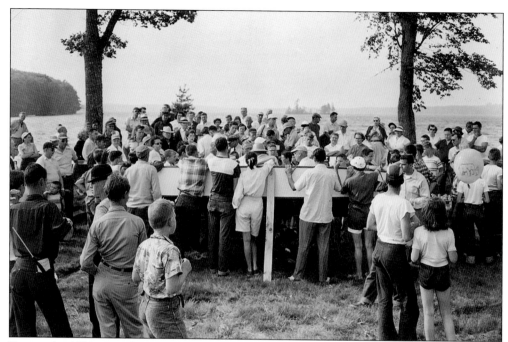

During the 1950s, speedboat races were organized and held off the shores of the Rick and Alice Jackson home (now the Rodrigue home) on Great Bay. The races were held in August, and spectators lined the shore while the hydroplanes, utility boats, and runabouts roared around the course. The whine and noise of the motors echoed for hours. The boats were divided into eight different classes of Mercury motors that ranged from 10 to 40 horsepower. There was one competition for 35-horsepower Johnson motors mounted on a Class C-D utility boat. This major summer event attracted significant numbers of competitors and spectators. The Jacksons belonged to an outboard racing club out of Westbrook, which sponsored the regattas. (Both, Newcastle Historical Society Dinsmore-Flye Collection.)

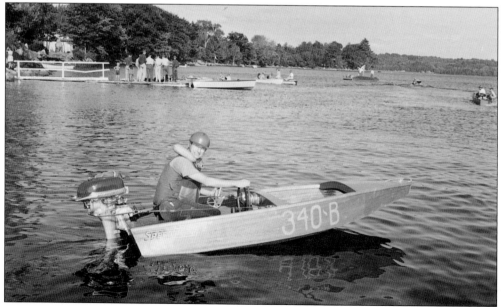

In 1952, a tractor-trailer truck loaded with 840 cases of Coca-Cola and other soft drinks jackknifed on the bridge over Davis Stream. The driver escaped serious injury by leaping from the cab into the river when the gasoline tank exploded. One of the crew trying to haul the truck back onto the roadbed was injured when the chain broke and struck him. Bystanders whiled away the accident scene clean-up time by drinking from the widely strewn bottles. Local teenagers slid bottles through the road drain gutters to the riverbed below, planning to retrieve them at a later date. The *Boston Globe* reported on Saturday, June 21, that Route 32 was blocked for several hours and traffic was detoured around Goose Hill and Linscott Roads. (Both, Marilyn M. Speckmann.)

www.arcadiapublishing.com

Discover books about the town where you grew up, the cities where your friends and families live, the town where your parents met, or even that retirement spot you've been dreaming about. Our Web site provides history lovers with exclusive deals, advanced notification about new titles, e-mail alerts of author events, and much more.

MADE IN THE

Arcadia Publishing, the leading local history publisher in the United States, is committed to making history accessible and meaningful through publishing books that celebrate and preserve the heritage of America's people and places. Consistent with our mission to preserve history on a local level, this book was printed in South Carolina on American-made paper and manufactured entirely in the United States.

This book carries the accredited Forest Stewardship Council (FSC) label and is printed on 100 percent FSC-certified paper. Products carrying the FSC label are independently certified to assure consumers that they come from forests that are managed to meet the social, economic, and ecological needs of present and future generations.

FSC
Mixed Sources
Product group from well-managed forests and other controlled sources

Cert no. SW-COC-001530
www.fsc.org
© 1996 Forest Stewardship Council

Find Your Place in History.